Art Educ

Issues in Postmodern Pedagogy

Art Education

Issues in Postmodernist Pedagogy

Roger Clark
The University of Western Ontario

Published as a collaborative effort by the

Canadian Society for Education through Art

and the

National Art Education Association
1916 Association Drive
Reston, Virginia 20191-1590

1996

By the Same Author:

Art Education: A Canadian Perspective

ISBN 0-9698237-0-3

In Canada,
copies may be purchased from the Canadian Society for Education through Art.

In the United States,
copies may be purchased from the National Art Education Association.

This book has been published as a result of the
North American Art Education Accord
between the
Canadian Society for Education through Art
and the
National Art Education Association.

ISBN 0-937652-94-6

■ Dedications

This book is dedicated to

Valerie & Peder Nielsen

and

Howard Craven

for their constant support and encouragement.

The educated lead the world.
We conclude from this that, next to parents,
teachers collectively hold more power than anyone in society.
The power of visual language was lost to the West a long time ago.
Its dormancy is one of our greatest losses,
unappreciated as such
because people today do not miss what they never had.
They fail to note the difference
between a frill subject and a subject of untapped power.

Dennis E. Fehr

▪ Contents

■ Figures

Acknowledgements

I would like to take this opportunity to thank

Janis Johnston
for her research assistance

and

Susan L. Brown
for her contributions to Chapter 3.

1 Deliberate Ambivalence

> A paradox of postmodernism - and perhaps its primary virtue -
> is that its ambivalence is deliberate.
> The notion of Truth is replaced with that of purposeful uncertainty.
>
> Dennis E. Fehr

Postmodernism is surely one of the most popular words of our time.

Postmodernism's popularity derives from its deliberate ambivalence and communicative elasticity: it can complicate or facilitate meaning. Referring to postmodernism in a conversation can allow individuals to appear profound without actually saying anything of real substance; alternatively, citing postmodernism can help groups find commonality within diversity. This communicative elasticity is the result of three characteristics of postmodernism:

- **Postmodernism is transitory**
 *Post*modernism suggests only what it is *not* rather than what it *is*. As has been the case with most previous breaks with convention, our present postmodernist era will likely acquire a defining title of its own only in retrospect by those promoting some future movement.

- **Postmodernism is transcendent**
 First gaining popular currency within the field of architecture, postmodernist theories can now be found within most disciplines, especially literature and sociology. This has spawned an array of specialized terminologies such as master narratives, simulacra, and decentred subject, as well as diversified perspectives such as poststructuralism, deconstruction, and reconstruction, making postmodernism as-a-whole difficult to discuss.

- **Postmodernism is transitional**
 Postmodernist theories do not always offer definitive departures from modernist principles. Feminist and postcolonial theorists, in particular, may speak from perspectives that are modernist, postmodernist, or somewhere in-between. An example of this transitional quality in our own field of art education is the continuing debate as to whether or not discipline-based art education (DBAE) is essentially modernist or postmodernist.

The elasticity of postmodernism, therefore, can be traced to its transitory, transcendent, and transitional characteristics; correspondingly, its deliberate ambivalence can be explained in terms of recent paradigmatic movements away from objectivity, rationality, and universality. Within the theory and practice of contemporary art these movements have produced new senses of meaning, connection, doubt, and perspective (Sullivan, 1993).

The sense of meaning within art has moved away from the modernist emphasis upon form toward issues of content, issues which frequently involve the concept of power - its source, exercise, and consequence. Artistic meaning is seen as a socially constructed entity, requiring the viewer to look beyond the formalist compositional qualities of a work, decode its symbolic imagery, and expose its embedded cultural assumptions. Meaning is also seen as fluid and contextual; a disparate array of interpretations can be derived from any given work since meaning is subject to the varied perspectives of artists and viewers.

Western societies have also experienced a paradigmatic movement away from fundamental laws and principles, especially those premised upon simplistic polarities. Modernist theories which explained social interaction in terms of opposing binary poles (male/female, capitalist/socialist, conservative/liberal) have been replaced by connective models that better reflect the multifaceted nature of human existence. In art, this new sense of connectivity has resulted in a rejection of the subject/object relationships that have historically existed between artist/model and artist/viewer.

The sense of doubt that underpins much of postmodernist theory stands in stark contrast to modernism's assumption of inevitable progress:

> Progress itself is questioned such that if the world as we see
> it today represents the best we can expect, then something is
> seriously wrong. (Sullivan, 1993, p. 13)

This element of doubt is so strong that postmodernism is more often than not attacked for its skepticism, cynicism, and nihilistic attitudes than for its central propositions.

Postmodernism has also provided art with a vastly increased sense of perspective. Less value is placed on the pronouncements of critics; more value is given to the voices of pluralism. Trends in art no longer take their cue from the avant-garde but from the vibrant forces unleashed within our corporate- and technology-driven mass culture. Inspiration, originality, and purity of form are out; appropriation, collage, and juxtaposition of meanings are in.

As we begin our investigation of issues within postmodernist art pedagogy it is important to remember that these four paradigmatic movements characterize postmodernism as-a-whole.

In Chapter 1 we shall be:
- discussing the legacy of modernism
- investigating the paradox of postmodernism
- examining the nature of ambivalent art.

1.1 Modernism

Elitism is often the whipping boy of social reformers. To be elitist
is to be removed from the values and competencies of the masses.
Well, what's wrong with elitism?
Perhaps educators *should* be concerned with expanding the elite,
that is, with enabling all people to learn how to participate in the
wonderful works that are found in all cultures throughout the globe.

Elliot W. Eisner

Before any discussion of postmodernism can be undertaken, we need
to take a step backwards, so to speak, and investigate what modernism means.
As we discovered in our attempt to define postmodernism, our task is made
more difficult by an ambiguity in terminology, for modernism functions as both
a perennial and a time-bound idea (Smith, 1992b):

> As a perennial phenomenon it relates to all those movements
> in the history of art when artists moved beyond traditional
> interest, however slowly, in order to be modern, to be of their
> time. For example, in departing from some of the
> conventions of Medieval art, Renaissance art can be said to be
> modern...As a time-bound concept, Modernism refers to the
> era of the avant-garde in the twentieth century. (p. 261)

Clearly, we are using the latter concept throughout this book.

For Ralph Smith, modernism refers to "the era of the avant-garde" - a
period during which radical artists rejected bourgeois society and set out to
replace conservative artistic conventions. The avant-garde's penchant for the
new and the *shocking* was a continuous process rather than a one-time event;
thus, the legacy of art during the twentieth century is one of successive change.
Metaphorically speaking, modernism can be considered a parade of visual styles,
each passing by the reviewing stand for a brief moment of critical acclaim.
Every new style follows the same route - setting out briskly at the periphery of
obscurity, reaching full-stride at the centre of recognition, and fading inexorably
at the edge of imitation.

For other scholars, however, modernism refers to Western humanist ideals held since the Enlightenment. This broader conceptualization emphasizes modernism's fixation with science, logic, perfection, and most of all progress:

> For the modernist period believed in scientific objectivity, scientific invention; its art had the logic of structure, the logic of dreams, the logic of gesture or material. It longed for perfection and demanded purity, clarity, order. And it denied everything else, especially the past: idealistic, ideological, and optimistic, modernism was predicated on the glorious future, the new and improved. Like technology, it was based all along on the invention of man-made forms, or as Meyer Shapiro has said, "a thing made rather than a scene represented." (Levin, 1979, p. 90)

The constancy of successive change within avant-gardism, considered by proponents to be evidence of continuous progress, made artistic judgement next to impossible, for rejecting past modes of expression invariably meant rejecting past standards for excellence, as well. This impermanence was reconciled with humanism's quest for order through the adoption of formalism as the primary method of understanding modernist art.

This approach was predicated on a consensus that the formal properties of art provided artists with the material content for expression and, in the case of viewers, the perceptual context for response. In both artistic expression and aesthetic response, the predilection of modernist art for heavily abstracted compositional elements (colour, line, shape, texture, and value) and formulaic compositional principles (balance, contrast, rhythm, *et cetera*) fostered the extended notion that formalism was inherently universal, that it afforded humanity a common framework within which art *ought* to be expressed.

The assumed universality and apparent simplicity of formalist theory suggested that understanding art was an innate human ability; no studio training or knowledge of art history was necessary to participate in modernist art. Influential figures within modernist art education, such as Frank Cizek and Viktor Lowenfeld, went even further by maintaining that adult interventions actually impaired child artistic development.

Modernist universality was, in reality, representative of a remarkably small universe inhabited almost solely by White males. The modernist focus on form as an objective universal transcending time and space obscured this unspoken domination, aided and abetted by the rampant denigration of representational subject matter:

> Social content - particularly explicit political matter was demoted...to irrelevance, as "sullying" the purity or impeding the "transcendence" of a work. (Piper, 1993, p. 58)

Postmodernist critics have justifiably pointed out that humanity fared rather badly under humanism, especially as expressed during the modernist era.

Since modernism emphasized the preeminence of form over content, artists looked inward for creative inspiration. Self-expression became an end unto itself, devoid of any other social function:

> For Dewey, the essence of art was not in the product or artifact, but in the act of experiencing through creation and perception...According to Beardsley, aesthetic experience had no practical purpose; it was to be enjoyed intrinsically. He set aside moral and cognitive aspects as being external to the experience, along with such features as the artist's intention and emotional effects. (Wolcott, 1996, p. 70)

At this point we need to return to the quotation by Elliot Eisner (1994) which began our discussion of modernist theory *(see page 3)*. In this passage, Eisner responds to the postmodernist charge of elitism within modernist art. How could modernism, which began as a liberal movement against conservative convention, have acquired a reputation for elitism? After all, didn't the universality of modernism provide an inherently democratic foundation for art?

The answer is quite simple: all revolutionary movements gradually become more conservative with the passage of time. By the Second World War, modernism had entered its final phase, usually referred to as high modernism (Holt, 1990). High modernism accentuated many features of modernism that, taken collectively, revealed a cleft between modernist art and the general public:

- **Disdain for popular tastes**
 A distinguishing feature of high modernism was its disdain for any form of popular art, which was given the ultra-campy name of *kitsch*. New styles were continually being sought by the *in crowd* to keep them aesthetically distanced from *trailer park habitués* across America. Public acceptance sounded the death knell for one style after another.
- **Denial of premodernist styles**
 A basic tenet of modernism from the outset, high modernism's denial of the past was absolute. The absence of traditional visual cues and representational subject matter made it difficult for the general public to understand high modernist art. Gallery patrons frequently wondered whether or not they were hapless participants in some elaborate hoax.
- **Disregard for non-Western cultures**
 The xenophobic tendencies of high modernism were most evident in the International Style of post-war architecture. Historic buildings were routinely razed in the name of urban renewal and replaced by steel-and-glass blocks that seemed to be as equally out-of-place in New Delhi as New Hampshire.
- **Deferral to art critics**
 High modernist theories of art criticism and aesthetics made ponderous reading for all but a small circle of art critics. This dense critical discourse further distanced the general public from modernist art.

It is interesting to note how deftly Eisner circumvents charges of elitism within modernism by assigning elitism the postmodernist virtue of cultural pluralism despite the historical legacy of Western cultural hegemony within modernism. This is but one example of modernism's ability to reconstruct itself, a phenomenon that we will revisit and explore at some length in Chapter 3.

Modernists more typically respond to charges of elitism by invoking claims to equality, democracy, excellence, and class mobility:

> The true apostles of equality are those who take for granted
> that the only ideal for a democratic society is one that prizes
> excellence and the pursuit of the best possible self, an ideal
> that far from being elitist in any maleficent sense is one that
> wants for the large majority what heretofore has been the
> privilege of the minority. (Smith, 1992a, p. 72)

The missionary zeal contained within such modernist declarations has not deterred postmodernist critics from pointing out that "the best possible self" alluded to is invariably White and male.

Before we move on to our discussion of postmodernism, it should be acknowledged that there are individuals who insist that postmodernism does not really exist, that modernist tenets continue to underpin most creative expression. For example, Fiona Blaikie (1992b) draws attention to the persistent disjuncture between fine art and popular culture as evidence of continuing modernism in Western culture:

> Modernism continues under the guise of postmodernism...The
> boundaries between high culture and popular culture are
> thriving rather than eroded. This is evident in that high and
> popular culture are *visible* as separate entities. One might
> readily find for sale at Goodwill or The Salvation Army
> sentimental paintings on black velvet of sad puppies and
> children, or sleeping Mexicans, but one does not find these
> images for sale at the Vancouver Art Gallery. (p. 21)

Blaikie also emphasizes the spark of avant-gardism that continues to fire creative expression:

> The idea of breaking new ground by defying artistic tradition
> is a modernist one, and it is, I believe, old hat. Yet
> modernism is still very much in evidence...This is because
> many artists continue to work within an ongoing genre of
> modernist concerns: They're *still* striving to be avant-garde.
> (p. 20)

Does postmodernism really exist? In the next section, we shall try to answer that question by looking at what the literature on postmodernism has to offer.

1.2 Postmodernism

> Attempts to define postmodernism
> appear to have muffled the best minds.
>
> Graeme Sullivan

In the summer of 1974 I was a third-year architecture student at the University of Waterloo. Our primary studio project for the term involved designing a library for a regional city of 300,000 in southwestern Ontario. Since the proposed site was a vacant lot within the central business district, my preliminary sketches proposed exterior elevations which complemented the surrounding Victorian architecture in terms of scale, materials, and detailing. Upon seeing these Victorian facades, my studio professor became very critical, summarily dismissing my sketches with a reminder that it was 1974, not 1874. I recalled his earlier lectures on the International Style and made the connection. In an effort to demonstrate that a more contemporary structure would be visually inappropriate, I sketched what I believed would be the most patently offensive: a miniature of Ludwig Mies van der Rohe's *Toronto-Dominion Centre* (1961).

Yes, of course, he loved it.

Although I did not realize it at the time, this incident was my first brush with the legacy of modernism. Being a typical university student, I dutifully submitted architectural plans for this glass-box library at the end of the term and, being a typical university instructor, my professor dutifully rewarded my newly found appreciation for glass boxes with an *A*. In retrospect, however, this was not just another example of a student playing up to teacher bias but an illustration, played out in countless studios during the early 1970s, of the generational shift away from modernism:

> Post-Modernism is not a style succeeding the dissolution of
> Modernism, but rather a cultural condition resulting from the
> erosion of Modern period ideals; it marks a historical moment,
> one of fairly slow germination, characterized by a shift in
> assumptions inherited from the Enlightenment. (Linker, 1985,
> p. 104)

In this section, we shall briefly look at the fundamental characteristics of postmodernism. The body of literature on postmodernism is very difficult to encapsulate because postmodernist theory has entered the discourse of virtually every discipline. As well, postmodernist concepts have acquired unique sets of nomenclature within some disciplines, producing a plague of competing terminologies. With these factors in mind, the following pages will attempt to present postmodernism in a straightforward manner, with a minimal degree of jargon, accompanied by illustrations drawn from art. Our discussion will be organized around three keystones of postmodernist theory: poststructuralism, deconstruction/reconstruction, and feminist/postcolonial criticism.

■ Poststructuralism

Linker's "shift in assumptions inherited from the Enlightenment" is commonly known as poststructuralism. It refers to the recent development of postmodernist philosophies which do not embrace humanist structures. One such structure involved the masterly figure of man, which found its expression within modernist art as "the autonomous, male fine artist who worked alone in a studio, freely self-expressing and intuitively creating" (Freedman, 1994b, p. 160). Postmodernist art educators have unmasked this fraudulent image of artist as male genius by shedding light on the social forces which enabled the great masters to gain their prominence. Just as the humanist image of rational, reasoning man replaced the theocentric emphasis upon God within pre-Renaissance thought, this phallocentric structure has, in turn, been displaced by postmodernism's preoccupation with the social forces at work within contemporary society and the conflicting interactions such forces generate.

Poststructuralism also maintains that grand explanatory systems such as history and science, which French literary critic Michel Foucault refers to as master narratives, are socially constructed. As such, they inherently offer subjective interpretations that relegate those objectified to positions of inferiority. This subject/object dynamic formed the core of modernist social theories, as seen within feminism (male/female), Marxism (capitalist/socialist), and political science (conservative/liberal). In art, this polarity found translation within the male artist/female model syndrome:

> Thus, the roles women most often play in art are those of
> observed subjects and carriers of meaning rather than makers,
> spectators, or interpreters. (Garber, 1990, pp. 20-21)

In the literature, questions of *"Who is watching?"* and *"Who is being watched?"* have given rise to the poststructuralist concept of the male gaze (Devereaux, 1990; Kaplan, 1986) which will be discussed in greater detail within Chapter 2. For postmodernists, the relationships that exist between the observer and the observed are not mere fodder for speculation, but insights into the nature of reality itself.

It is also important to note that poststructuralism questions the existence of epistemological absolutes such as truth, certainty, reality, or beauty. In their stead, postmodernists rely upon "persuasive rhetoric, arguing from information rather than knowledge, and accepting that information is always provisional" (MacGregor, 1992, p. 2). This represents a major departure from the tenets of modernism which treated absolutes as articles of faith. The loss of their humanist moorings has, in many cases, caused more angst among modernists than the propositions actually advocated by postmodernists. To understand why, we need to recognize the stream of positivism which ran throughout modernism -a belief that fundamental laws which governed our existence could be controlled and exploited to ensure a brighter future for mankind. For modernists, the pessimistic sense of doubt which envelopes postmodernism contrasts negatively alongside the optimistic notion of progress which permeated modernism. Thus, where postmodernists see noble intent and liberatory action, modernists see only nihilistic attitude and destructive critique.

■ Deconstruction/Reconstruction

We have already touched on the poststructuralist proposition that forms of knowledge do not exist as universal absolutes, but are constructed by people living within communities. Three principles drawn from cultural psychology drive this process (Cole, 1990):
- Learning and social interactions are mediated by the artifacts of earlier generations.
- Learning and social interactions are passed on to successive generations.
- Learning and social interactions are modified by successive generations.
This phenomenon is called constructivism, which plays a critical role in both art and education. When we ask students to create, they do not work from a blank slate, so to speak. Even before the art lesson begins, they possess a bank of knowledge, acquired from society-at-large, known as cultural capital; but this social conditioning establishes parameters within which the students create, for "We are "constrained" characters that develop along certain permitted physical and social paths that are etched into our being" (Sullivan, 1993, p.6).

Logically, it follows that whatever is socially constructed can also be deconstructed, or taken apart, to expose the social forces embedded within:

> Post-Modernism thrives on…differences, which are as evident in artifacts as they are among individuals…Ambiguities and surprises are sought, together with multiple references. The audience may be confronted with paradoxes arising from unlikely choices of material, or from allusions to discrepant periods in art history, or from cultural contradictions. (MacGregor, 1992, p. 2)

In contrast to modernism's focus upon purity of form, postmodernism is concerned with interpretation of meaning. Thus, deconstruction lies at the very heart of postmodernist art; however, since artists and viewers alike engage this process from diverse perspectives, their resultant interpretations of meaning will of necessity be similarly diverse. This phenomenon is referred to in the literature as reconstruction.

Postmodernism's predilection for multiple interpretations of meaning provides yet another departure from modernist art. Modernism's reliance upon canonical master works and the pronouncements of art critics has been replaced by pluralist views of art production and reformist approaches to art criticism. The impact of these two postmodernist trends can perhaps be most clearly seen in recent changes to museum education (Stone, 1995a, 1995b; Vastokas, 1996). Despite the current widespread scarcity of funding for new acquisitions, art museums are struggling to enrich their predominantly Eurocentric permanent collections with non-Western exemplars. As well, docent courses and education programmes are being restructured to provide greater attention to global issues. These reforms in museum education reflect the profound contributions made to postmodernism by scholars working in the field of critical theory, principally in feminist and postcolonial criticism. Introduced briefly here, these two pivotal features of postmodernism will be more fully discussed in Chapter 2.

▪ Feminist/Postcolonial Criticism

Although the field of critical theory has received considerable attention since the end of the Second World War, its emphasis upon social reform is yet another legacy of the Enlightenment. The evolution of democracy, abolition of slavery, eradication of child labour, and enfranchisement of women are all examples of how earlier forms of oppression were defeated through extended exposure to public scrutiny by determined activists. Feminist and postcolonial critics find distinction within the larger arena of critical theory due to their particular emphases - in the case of the former, sexism, and the latter, racism.

This historical time-frame is important to keep in mind when discussing feminist and postcolonial literature, because some of it is modernist and some of it is postmodernist. Modernism, as we have seen, traditionally conceptualized social conflict in terms of binary polarities; for feminism this meant a focus on male/female dynamics, for postcolonial criticism it meant a spotlight on White/non-White interaction. Postmodernism, on the other hand, sees social conflict through multiple perspectives. For example, postmodernist feminist researchers go beyond studying how women's lives are affected by men, to explore how women's lives are affected by other social forces, such as age, class, ethnicity, race, and sexual orientation. Of equal importance is the fact that their research no longer refers to men in any fixed sense, but acknowledges that men are also subject to the diverse array of social forces that affect women.

Postmodernist feminist scholarship has drawn attention to practices within modernism that traditionally restricted women's participation and recognition in art:

> Feminists reject the thrusts of modernism in art that have emphasized genius, originality, and self-referentiality - qualities associated with male development...Over the course of the past century and a half, *artist* has been thought of as an antisocial, antidomestic free-thinker, while women's roles have been associated with social reproduction and cultural refinement. (Garber, 1990, p. 17)

Feminist researchers have made significant contributions to educational theory by emphasizing the importance of collaborative, nurturing pedagogies - strategies easily incorporated within art education, but all too frequently absent from art academies (Wainio, 1995). Of even greater importance, however, has been feminism's success in raising public sensitivity to systemic biases which assume male experience to be universal.

Postcolonial criticism is largely concerned with the study of literature; the term is virtually unknown in art education, where race research is traditionally subsumed within the less controversial rubric of multiculturalism. The roots of Eurocentric biases in school art curricula have been addressed, however, by Canadian art education historian Graeme Chalmers, who cites ethnocentrism, racism, prejudice, and geographical determinism as contributing catalysts. His research underlines, once again, the impact of modernism's preoccupation with structural order:

> Marsden (1990) shows that nineteenth-century essayists, poets, and novelists were very attracted to hierarchical constructs. Both the noble savage and the lazy native became stereotypes that were underpinned by a geographic determinism which regarded the continuum from sloth to vigor as being caused by climate. (Chalmers, 1992a, p. 140)

As farcical as this emphasis upon climate may seem to us today, other Victorian views on the art aptitudes of non-Whites were decidedly more serious and, unfortunately, more lasting:

> [The Negro is] slow of temperament, unskilled, his mechanical ingenuity being that of a child; he never goes beyond geometrical ornamentation;...his imagination [is] slow...He cannot create beauty, for he is indifferent to any ideal conception. (Zerffi, 1876, pp. 239-240)

While the overtly racist assumptions contained within this passage may seem incompatible with our contemporary, more benign understanding of modernist art, the more subtle elements can be readily correlated to tenets of modernism: ornamentation *versus* fine art, beauty as a fixed concept, and deference to assumed ideals.

In our overview of postmodernism thus far we have introduced the basic concepts underpinning poststructuralism, deconstruction/reconstruction, and feminist/postcolonial criticism. Having considered these component parts, perhaps we should now turn our attention to more global conceptualizations of postmodernism (Haynes, 1995).

At the outset, we need to appreciate that the diverse avenues of research within postmodernism have not developed along parallel strands. Given the wildly eclectic nature of postmodernism, we should not be surprised to discover theories which are at once both radical/conservative, historical/futuristic, or idealistic/nihilistic. In our own field of art education, the chameleonic discipline-based art education (DBAE) is an example of postmodernism's ability to simultaneously accommodate theoretical polarities.

Postmodernism may also be conceptualized historically. Various events have been characterized as the defining moment when we entered postmodernity: the Holocaust, the publication of Betty Friedan's *The Feminine Mystique*, the voyage of Apollo 11...or the design of a Miesian library. Whatever the actual point of departure, postmodernism represents a critical shift in historical perspective.

A third view of postmodernism centres on the profound changes in Western culture since the Second World War, changes which have impacted postmodernism on two levels: academic and contemporary (West, 1993). While the academic culture's preoccupation with topics such as subjectivity and identity occupies most of the literature on postmodernism, West maintains that, of the two, contemporary culture has made the greater contribution to postmodernist existence:

> The actual determinants of postmodern culture lie...in the
> impact of market forces on everyday life; in the United States'
> displacement of Europe as the major global influence (and
> possibly the present displacement of the U.S. by Asia); in the
> polarization of contemporary culture around issues of
> ethnicity, race, gender and other differences in identity; and
> in the general bureaucratization of ideas. The breakdown of
> categories of high and low art, the commodification of culture,
> and commercialization of the arts are the results of these
> interrelated forces. (Haynes, 1995, p. 46)

We have already discussed the diminished role played by the avant-garde within postmodernism and the increased attention paid to groups traditionally marginalized by the modernist elite. In the next section, we will discuss how these two factors have contributed to fundamental changes in art - changes which have moved the epicentres of postmodernist Western culture away from studios and museums into boardrooms and living rooms.

1.3 Ambivalent Art

> Poststructuralists argue further that narrative knowledges
> are in some ways less deluded about their own status;
> unlike scientific knowledge, they acknowledge,
> sometimes even foreground,
> their own figurative and ambiguous status.
> Art is an excellent example of this tentative, figurative,
> almost postmodern way of seeing and knowing.
>
> Cydney Keith

Writing in his 1990 book *A History of Art Education: Intellectual and Social Currents in Teaching the Visual Arts*, Arthur Efland speaks of two distinct "streams of influence" which have competed for dominance throughout the history of general education. He calls curricular ideologies rooted in science scientific-rationalist and those grounded within the arts romantic-expressive. Efland presents a chronological scheme which illustrates how both streams have contributed in equal measure to the development of American education since 1900 *(see Figure 1: Historical Patterns in General Education)*.

We can, of course, trace scientific-rationalist and romantic-expressive camps within education back much further than 1900:

> According to Plato, all knowledge must be stateable in explicit definitions that any one can apply. If one could not state his know-how into explicit instructions - if his knowing *how* could not be converted into knowing *that* -it was not knowledge but mere belief. Cooks, for example, who proceed by taste, craftsmen who use intuition, poets who work from inspiration, and prophets, like Euthyphro, who preserve the tradition have no knowledge; what they do does not involve understanding and cannot be understood or taught. (Dreyfus & Dreyfus, 1984, p. 580)

Clearly, the curricular gulf between empirical and narrative forms of knowledge has an ancient history.

	Scientific-Rationalist Stream	**Romantic-Expressive Stream**
1900-1918	Social Efficiency	Romantic Idealism
1929-1940	Instrumentalism	Creative Expression
1959-1965	Discipline-Centred	Counterculture
1965-1980	Accountability	Qualitative Inquiry
1980-	Excellence	Critical Theory

Figure 1: Historical Patterns in General Education

(Efland, 1990a, 1990b)

For our purposes, however, Efland's chronology is especially useful because it begins at the turbulent birth of contemporary education. At the turn of the century, educational theorists were still in the process of inventing the modern secondary school. The latter half of the 1800s had witnessed the demise of grammar schools and the proliferation of practical subjects within the newly emergent secondary schools. The ever-increasing diversity of secondary school curricula, however, forced educators to revisit the question of how society could determine the relative importance of individual school subjects.

In the United States, the National Education Association (NEA) established the Committee of Ten on Secondary School Studies, a panel of academics led by Harvard president Charles Eliot. Their 1894 *Report* recommended that all secondary school students study a common curriculum of nine subjects: Latin, Greek, English, modern languages, mathematics, physics and chemistry, biology, history and politics, and geography; drawing and music were relegated to the status of electives. Despite the Committee's support for classical and modern languages, the new secondary school curriculum soon demonstrated its scientific-rationalist cast. In the new age of science, all subjects felt compelled to demonstrate their *productive* value to society. For art, this meant the study of nature, and the nineteenth century Kensington preference for geometric drawing was replaced by the direct observation of natural forms.

The ink had barely dried on the Committee on Ten's *Report* when another NEA commission, known as the Committee of Fifteen, countered with a predominantly romantic-expressive syllabus for elementary school studies (NEA, 1895). Headed by William Torrey Harris, this second Committee proposed "five windows on the soul or basic divisions of knowledge": history, geography, grammar, literature, and arithmetic. While once again officially placing art in a position of curricular inferiority, the Committee of Fifteen did recommend that elementary education focus on narrative forms of knowledge:

> Although the "three R's" remained a significant component of
> the curriculum, the elementary school became a place where
> learning occurred through a variety of activities from
> participating in plays and the writing of poetry to craft work
> and dancing. (Longstreet & Shane, 1993, p. 24)

Its inability to gain compulsory status in either elementary or secondary school curricula forced art to find new grounds upon which to rationalize its continued presence in North American schools. Two survival strategies were widely adopted by the First World War: instrumentalism or essentialism.

■ Instrumentalism

Instrumentalists maintained that art should be part of school curricula, not so much for its own inherent value, but because it facilitated the acquisition of broader curricular objectives, such as motor control, cooperative work habits, visual perceptiveness, and willingness to express ideas. For example, the curriculum of John Dewey's laboratory school at the University of Chicago included both fine and applied art activities, but they were taught within the context of child-centred themes, rather than as discrete subject areas.

The roots of this proposition can be found in the 19th century accomplishments curriculum designed to prepare upper-class, young women for participation in society (Soucy, 1989; Zimmerman, 1991) and the romantic-idealistic notion that the arts could foster social regulation through the study of great civilizations from the past. It would be a mistake, however, to consider instrumentalism as primarily romantic-expressive; indeed, instrumentalism found its greatest ally in the emergent field of developmental psychology. At the core of developmentalist orthodoxy was the belief that all children were natural-born artists; as such, they moved innately through stages of artistic development. Viktor Lowenfeld, in his seminal 1947 text *Creative and Mental Growth*, offered the extended notion that creative activities played a critical role in the promotion of mental health. The instrumentalist coupling of artistic activity with psychological development proved to be widely successful, allowing art to keep a toehold in elementary curricula throughout most North American schools as a form of *compulsory elective*. Unable to capitalize on this child-centred argument, art in most secondary schools remained deeply marginalized.

In more recent years, a new slant to instrumentalist advocacy for art has emerged, this time from the field of sociology. Critical theorists have pointed to the role played by art in camouflaging the overtly competitive nature of schooling, which sociologists link to the systemic marginalization of minorities by class, gender, and race:

> Art is one area of the curriculum that subject-matter experts
> have not been allowed to structure and control because non-art
> teachers and parents want art to play a special supporting,
> compensatory role in the schools. When art programs do not
> perform their "feminine" duties, do not nurture and decorate,
> non-art teachers and parents feel free to complain. Art, after
> all, is not basic. (Collins, 1995, p. 79)

Thus, the instrumentalist strategy for promoting art within general education consisted of three distinct, but allied, propositions:

- Art facilitated generic learning.
- Art promoted psychological well-being.
- Art encouraged social harmony.

Transformed from a second-string school subject into a cross-disciplinary pedagogic methodology, art activities found widespread acceptance within elementary curricula as complements to Jean Piaget's psychological model of cognitive development, Maria Montessori's pedagogic model of auto-education, and John Dewey's curricular model of active learning.

Instrumentalism is referred to in the literature as arts-in-education, a 1960s and 1970s movement characterized by:

- an emphasis upon arts in the plural
- a tendency to seek solutions to educational problems outside of the school proper
- an inclination to involve community agencies as resource persons
- a bias in favour of studio production/performance
- a propensity for justifying arts education in terms of social and/or remedial enhancement. (Efland, 1990b)

Curricula which cluster the four arts - art, dance, drama, and music - have been revisited during the 1990s in response to increasingly crowded school timetables. So, before leaving this discussion of instrumentalism, perhaps we should take a deeper look at the pedagogic structure of the arts-in-education movement. One of the best known proponents of arts-in-education is Canadian Richard Courtney, whose media-based model of learning is outlined in *The Dramatic Curriculum* (1980), *Re-play* (1982), and *Play, Drama & Thought* (1989): Learning is the ability to use the skills of the media. It

> occurs, first, for expressive purposes and thereafter for critical
> purposes, so that the student can increasingly express his
> meanings to others. (Courtney, 1982, p. 11)

So far, so good. Courtney's theory certainly sounds inclusive. Art educators, however, will be deeply dismayed to discover that the accompanying diagram *Figure 3: The Development of Media* (Courtney, 1982, p. 11) contains only three learning strands: a central line for drama, flanked by strands for music and dance. Apparently, art media do not contribute to learning.

■ **Performing Arts**

To understand why art is pedagogically distinct from the performing arts, we need to look closely at Courtney's notion of "the dramatic curriculum":

> Dramatic action serves a clear purpose in life. It is the prime
> mediator between our inner selves and the environment. It is
> a medium whereby our inner self works with the outer world
> and creates meaning out of it. Drama is a bridge, a filter,
> between the two worlds. (Courtney, 1982, pp. 5-6)

At the outset, Courtney's concept of dramatic action matches Rollo May's description of creative courage: both involve an encounter between the subjective self and the objective world (May, 1975, p. 150). But drama becomes the "prime mediator" in Courtney's model due to his limited notion of Being: For imaginings to become externalized, we need to act with

> them. When we are very young this is *to Be* - "I am an
> airplane." Once this is achieved, the child can extend the
> action to *elements* of Being: *to Sound* - "I make the sound of
> an airplane"; and *to Move* - "I make the movements of an
> airplane." (p. 8)

Courtney's three strands of Being, which translate into drama, music, and dance, share a common dependence upon corporeal action. For Courtney, Being requires a direct, bodily expression - in other words, a performance. What Courtney's model fails to acknowledge is that there is "no one way of being," to borrow a phrase from the title of his 1988 study into the practical knowledge of elementary school teachers. "For imaginings to become externalized" we do not need "to act with them." We are not limited to pretending that we *are* an airplane, to *sounding* like one, or to *moving* like an airplane. We can *draw* an airplane or *construct* one, as well.

It is this lack of direct, corporeal action that separates art from the performing arts. Artists are not hanging in our galleries, nor do we usually see their activities in the studio. Art is an indirect encounter between the subjective self and the objective world. It might be worth noting at this point that art is not the only indirect arts discipline. Language, computer, film, photography, and video arts also function indirectly, and the whole language process closely parallels studio processes used in art education. School administrators wishing to cluster subject areas might well be advised to link art education with language arts rather than with the performing arts (Clark, 1995).

■ **Essentialism**

The alternative political strategy devised to support school art is called essentialism. Rather than rationalizing art's contribution within general education in terms of its ability to facilitate the acquisition of generic curricular objectives, psychological well-being, or social harmony, essentialists maintain that art has inherent value as a discrete school subject. It should be understood that essentialism is not primarily associated with art advocacy, rather, the term refers to a broadly-conceptualized educational philosophy:

> This philosophy of education emphasizes our cultural heritage and the need to pass on to the young the skills and knowledge essential to the continued functioning of our society. Mathematics, the sciences, and other stores of basic knowledge are the foundations of learning. While essentialism does not conceive of knowledge as absolute, it does give great importance to time-tested content that has proved its worth to society. (Longstreet & Shane, 1993, p. 112)

Convincing the general public, however, that art forms an essential component of "the foundations of learning" has not been an easy task:

> A recent Gallup Poll [Elam, 1990] on the American public's attitudes toward the public schools reported that in response to the question "what subjects would you require every public high school student who plans to go on to college to take," art and music ranked at the bottom of a list of fourteen at 24% (art) and 22% (music). The percentages were lower (17% and 16%) for those not planning to go on to college. (Pearse, 1992b, p. 85)

It is interesting to note that Gallup asks the American public to rate high school subjects in terms of their value for college, rather than their value for secondary education. This is not simply a question of semantics; the deliberate choice of "college" reflects the historical role played by universities in the selection and organization of high school subjects. Art remains a low-status school subject for two basic reasons, both of which relate directly to postsecondary education:

■ It is not required for college entrance.

■ It is not usually subjected to standardized testing.

The results of pressures placed upon high school curricula by university specialists and committees are wholly predictable:

> School subject groups tend to move progressively away from concerns with "utilitarian" or "relevant" knowledge. High status in the secondary school curriculum is reserved for abstract theoretical knowledge divorced from the working world of industry and the everyday world of the learner. (Goodson, 1987, p. 197)

We have already discussed the imprint left by university-dominated educational commissions during the development of elementary and secondary school curricula at the turn of this century. University-based laboratory schools, such as John Dewey's institute at the University of Chicago, continued this tradition through the 1920s and 30s by undertaking innovative research into educational theory and practice.

University scholars again played a significant role in school reform during the 1950s as Cold War rivalries heated up. Fears that Western education was not sufficiently rigorous prompted critics to demand a greater emphasis upon discipline-based curricula. The Soviet launch of *Sputnik I* in 1957 made science and mathematics the earliest, and easiest, targets of such reform, but pressure was exerted upon all subjects to prove that they were worthy of continued presence in American schools.

Art educators were faced with a much more daunting task in this regard than their colleagues in science and mathematics. In order to demonstrate that art was a rigorous discipline, a "foundation of learning" as it were, art educators had to overcome two educational legacies (Clark, 1993, 1994):

- art's gradual dissolution within elementary school curricula into a cross-disciplinary pedagogic methodology
- art's historical emergence within secondary school curricula as drawing, a vocational course in mechanical illustration.

In the mid-1960s, university scholars such as David Ecker and Manuel Barkan put forward the essentialist propositions that:

- artistic activity was a form of qualitative problem-solving
- the discipline of art consisted of three modes of scientific inquiry: studio, art history, and art criticism.

This early form of discipline-based art education (DBAE) greatly reduced the time spent in studio production and, correspondingly, significantly increased the attention paid to art history and art criticism.

Efland's chronological scheme, as presented in *Figure 1 (see page 14)*, clearly demonstrates the cyclical nature of educational reform. The publication of *A Nation at Risk* by the U.S. Commission on Excellence in Education (1983) rattled American nerves much as *Sputnik I* had spooked American fears in the late 1950s. Discipline-based art education was again promoted by essentialists as a model for excellence in art education, but this time around DBAE had an influential sponsor, the J. Paul Getty Trust. Through the Center for Education in the Arts, DBAE's four-part model of studio, art history, art criticism, and aesthetics was widely promoted throughout the United States:

> Now more than ever, all people need to see clearly, hear acutely and feel sensitively through the arts. These languages are no longer simply desirable but are essential if we are to convey adequately our deepest feelings, and survive with civility and joy. (Boyer, 1985, p. 9)

In addition to advancing the proposition that art is an academically rigorous discipline, essentialists have advocated the continued presence of art in American curricula by pointing to recent research in multiple intelligences undertaken by arts educator Howard Gardner. Working with the Rockefeller Foundation in an arts assessment programme called *Project Zero*, Gardner has suggested that there are at least seven forms of human intelligence: mathematical, linguistic, musical, spatial, bodily-kinaesthetic, interpersonal, and intrapersonal (Gardner, 1983, 1989).

Project Zero was conceptualized as a response to the public's tacit belief that schools frequently fail to tap non-academic forms of student ability. Gardner's theory of multiple intelligences offers an explanation for why students who do poorly in school often succeed later in careers that focus upon non-academic abilities. The repeated emphasis upon mathematical and linguistic forms of intelligence within most core academic subjects accounts for why students often perform equally well, or equally poorly, across a range of what are supposedly different courses. As well, the heavy reliance upon mathematical and linguistic abilities in psychometric tests and university entrance examinations explains why they appear to be such reliable predictors of student academic aptitude.

The theory of multiple intelligences is clearly at odds with the psychometric notion of a stable and singular form of human intelligence, a concept which has been deeply entrenched within educational practice for most of this century. Should Gardner's theory be true, and "the arguments and data are persuasive" (Abra, 1988), existing school curricula are failing to educate holistically. Many of our present school dropouts may, indeed, be quite intelligent, after all.

Essentialists maintain, therefore, that:
- curricular reform based upon research into multiple intelligences is urgently required
- art needs to be an integral component of any holistic curriculum.

It should be further noted that since Howard Gardner's theory of multiple intelligence involves musical, spatial, and bodily-kinaesthetic forms, school curricula should also include dance, drama, and music.

Thus, the ambivalent role played by art in contemporary education can be traced back to the turn of this century when university-based committees refused to recognize art as a required school subject. At the elementary level, instrumentalists managed to secure a continued presence for art, not as a discrete subject, but as a cross-disciplinary pedagogic methodology. At the secondary level, essentialists advocated for art's continued status as a discrete subject area using discipline-based curricula and holistic research to gain public acceptance. This Janus face of art presents educators with a curricular discontinuity that must be reconciled if art is to survive the challenges facing education in the next century.

The resultant pedagogic ambivalence between education *through* art curricula at the elementary level and education *in* art curricula at the secondary is primarily philosophical, the former being associated with instrumentalism and the latter with essentialism. *Figure 1: Historical Patterns in General Education*, places both instrumentalism and essentialism under Efland's scientific-rationalist "stream of influence," however, we can identify romantic-expressive influences within both curricular philosophies. For example, instrumentalism promotes art within general education as an agent of psychological well-being and social harmony, phenomena deeply rooted in Efland's romantic-expressive categories of creative expression and critical theory. Similarly, essentialism promotes art as an academic discipline consisting of studio, art history, art criticism, and aesthetics, a romantic-expressive concept of art which contrasts sharply with 19th century drawing's vocational emphasis upon mechanical illustration. Clearly, Efland's scientific-rationalist/romantic-expressive dichotomy does not provide an internally consistent conceptual framework for discussing the current state of pedagogic ambivalence within art education.

■ Forms of Knowing in Art Education

There exists another form of ambivalence within contemporary art education - a cognitive ambivalence which arises from the disparate forms of knowing which underpin professional practice. Canadian art educator Harold Pearse (1983, 1992a) has constructed a model of cognitive styles in art education which has been charted within *Figure 2: Forms of Knowing in Art Education*. Pearse began with a tri-paradigmatic framework conceived by Jurgen Habermas (1971) "to identify and analyze the structure of three basic forms of knowing that have characterized modern thought and action" (Pearse, 1992a, p. 244). Before going any further, it might be helpful to pause awhile and define what is meant by a paradigm:

> A paradigm is commonly described as any pattern, example, or model. Educational theorists and social scientists use the word to denote ways in which knowledge and behaviour are structured or organized. In its broadest terms, a paradigm is a world view. Although seldom consciously articulated, a paradigm is an internally consistent orientation from which a conceptual and operational approach to functioning in the world is constructed. A paradigm may be likened to a view finder, and new paradigms provide different points of view. Hence, when a new world view appears, one speaks of a paradigm shift (Kuhn, 1970). (p. 244)

Thus, the forms of knowing in art education presented in *Figure 2* are predicated on three world views: empirical-analytic, interpretive-hermeneutic, and critical-theoretic.

	Paradigm I	**Paradigm II**	**Paradigm III**
Orientation	empirical-analytic	interpretive-hermeneutic	critical-theoretic
Root Activity	work	communication	reflection
Emphasis	▪ products ▪ facts ▪ skills ▪ techniques	meaning	critical action
Approach	subject	child	society
Outcomes	▪ objects ▪ competencies ▪ behaviours ▪ accountability	reality of everyday life	critical consciousness

Figure 2: Forms of Knowing in Art Education

(Pearse, 1983, 1992a)

Each of the three world views which underpin Pearse's forms of knowing in art education represents a distinct set of goals and values. As was the case with Efland's streams of influence, these paradigms find their warrant in philosophy, but do not correspond completely with any single philosophic perspective.

At first glance, Pearse's model may appear to be very similar to Efland's; it is easy to parallel the empirical-analytic and interpretive-hermeneutic paradigms with Efland's scientific-rationalist and romantic-expressive streams. The third paradigm, critical-theoretic, can also be easily aligned with Efland's final romantic-expressive category of critical theory. It is important to understand, however, that Efland's model was conceptually pedagogic and internally structured around historical trends in general education, whereas Pearse's model is conceptually cognitive and internally structured around forms of knowing in art education.

■ Paradigm I: Empirical-Analytic

This world view places primary value upon technical forms of knowing. Facts, generalizations, theories, and cause-and-effect laws are some examples of empirical-analytic knowledge. Empirical-analytic precepts have traditionally provided the structure for educational research, where experimenter control, validity, and generalizability are critical components; however, since education is a social process and inherently subjective, the limitations of experimental studies have become increasingly apparent. Nonetheless, empirical research remains effective when factual, statistical information is required. The root activity (Pepper, 1942) within Paradigm I is intellectual/technical work that furthers our understanding of the natural world. Efficiency, certainty, and predictability characterize such work. Art curricula premised upon empirical-analytic forms of knowing are subject-centred and typically stress products, facts, skills, and techniques. Outcomes are measured in terms of objects, competencies, behavioural objectives and accountability.

■ Paradigm II: Interpretive-Hermeneutic

Situational forms of knowing receive prominence in this second world view. The paradigm is deeply grounded within phenomenology (Husserl, 1964) which involves moving beyond the particulars of a lived experience to see its universal essence, or deep structure. The root metaphor within interpretive-hermeneutic forms of knowing is communication, that is, relating people to their social world. Paradigm II research is conducted within the discipline of hermeneutics, the study of understanding and interpretation. This form of knowing lies at the heart of Max van Manen's (1990, 1991) conviction that neither educational theories nor instructional models can fully prepare teachers for curricular moments, those times in which teachers interact directly with their students. He believes that pedagogy is conditioned by love, care, hope, and responsibility for children and, further, he suggests that pedagogic understanding is best achieved through sensitive listening and observing. When dealing directly with students, teachers should employ pedagogic tact, a subjective insight which van Manen defines as "the practice of being oriented to others." Although pedagogic tact cannot be planned in advance of curricular moments, it manifests itself in: holding back, being open to the student's experience, being attuned to subjectivity, influencing students subtly, displaying situational confidence, and being able to improvise when the need arises. Pedagogic tact operates through speech, silence, eye contact, gesture, atmosphere, and by example. Art curricula based on interpretive-hermeneutic forms of knowing are child-centred, "yet, essentially, the educational process is seen as a dialogue with others and with oneself, in the world of things, people, and ideas" (Pearse, 1992a, p. 245).

▪ Paradigm III: Critical-Theoretic

The world view represented by this still-evolving paradigm is focused on forms of critical thinking which encompass both reflection and action. *Praxis*, the reciprocity of thought and action, forms the core of this perspective. Whereas clear distinctions may be readily drawn between Paradigms I and II, such is not the case for the conceptual span between Paradigms II and III. The critical-theoretic orientation is best regarded as an extension to the interpretive-hermeneutic, for Paradigm III adds a critical dimension to situational meaning:

> The root activity in the critical orientation is reflection, or the relating of man to his self and his social world. Its fundamental interest is emancipation and improvements of the human condition by rendering transparent tacit and hidden assumptions and by initiating a process of transformation designed to liberate man. (Pearse, 1983, p. 161)

Art curricula premised upon this paradigm emphasize relationships between the visual world and the social world, relationships which reveal how injustices within society marginalize certain groups by virtue of their class, gender, or race. The literature associated with Paradigm III is dominated by scholarship drawn from the fields of feminism and social criticism. Within art education, early contributors to this research domain included Kenneth Marantz and Vincent Lanier. During the past decade, however, feminism and social criticism have become the focus of a great many more art educators; overviews of their research will be presented in Chapter 2.

Since the literature surrounding Paradigm III is dominated by research focused upon feminism and social criticism, at first glance it may seem logical to situate postmodernism within the critical-theoretic world view. As pointed out earlier, however, feminists and other critical theorists may speak from perspectives that fall anywhere along a modernist-postmodernist continuum; therefore, we cannot confidently locate postmodernism within Paradigm III simply on the basis of shared research agendas.

Upon closer inspection, it becomes evident that the tri-paradigmatic model of cognitive styles presented in *Figure 2*, originally devised by Habermas and later applied to art education by Pearse, is premised on forms of knowing which are, in essence, modernist. Thus, the sense of cognitive ambivalence associated with postmodernism is not adequately captured by the root activities of work, communication, or reflection:

> Conversations about postmodernism among artists, educators, and others contain words like *disturbing, unsettling, discomforting*. Postmodernism, even if it could be defined, cannot be easily accommodated within any existing paradigmatic structure. I think I feel the rumblings of paradigms shifting. (Pearse, 1992a, p. 247)

■ Western Conceptions of the Artist

In his 1988 text *Wake of the Imagination*, Richard Kearney presents a paradigmatic model based on shifts "which signal decisive mutations in the human understanding of imagination during different epochs of Western history" (p. 17). Kearney's model is especially useful for our purposes for two reasons:
- It directly addresses postmodernist theory.
- It is conceptually creative and internally structured around Western conceptions of the artist.

The model is also interesting because imagination, like postmodernism, is a word which does not really define anything because of its broad meaning and usage. Kearney's model offers three paradigms, or world views: premodernist, modernist, and postmodernist *(see Figure 3: Western Conceptions of the Artist)*.

■ Premodernist Paradigm

During the premodernist era, creative expression was characteristically theocentric. In illuminated manuscripts, stained glass windows, and cathedrals medieval artists strove to complement the divine handiwork of God, the original Creator:

> Imagination remains largely a *reproductive* rather than a *productive* activity, a servant rather than a master of meaning, imitation rather than origin. (Kearney, 1988, p. 133)

This mimetic orientation placed primary emphasis upon the attainment of production skills, and artists were considered to be craftspersons. Kearney uses the root metaphor of a mirror to capture the premodernist paradigm - the mirror reflecting a light of transcendental origin beyond itself, from God.

While Kearney relies heavily upon a medieval context for this mimetic orientation, the premodernist paradigm of the Western artist as craftsperson has classical antecedents (Feldman, 1982). Roman and Greek artisans received training in a craft at home; sons were taught by fathers, daughters by mothers. State laws made it difficult for children to leave his or her parent's occupation. Workshops provided the primary venues for learning trades, although there were informal apprenticeships of varying duration. Since ancient craftspersons were considered to be only marginally better than slaves, work in trade shops was characteristically routine, dull, and frequently dangerous. The belief that tradespersons laboured under the protection of particular divinities provided a religious subtext to the attainment of technical skill:

> Little or no attention was paid to artistic expressiveness because no one, including the craftsman, thought the artisan's psyche or soul was particularly worthy of interest. (Feldman, 1982, p. 57)

	Premodernist Paradigm	Modernist Paradigm	Postmodernist Paradigm
Orientation	mimetic	productive	parodic
Root Metaphor	mirror	lamp	looking-glass
Artist	craftsperson	inventor	collagist

Figure 3: Western Conceptions of the Artist

(Kearney, 1988)

Thus, classical artistic expression reflected both social and religious customs; cult observance and respect for tradition underpinned premodernist Western conceptions of the artist. The craftsperson's mystique, a notion which continues to fuel contemporary debate about art *versus* craft, was built upon four social and psychological factors:

- the sense of working for a divine patron
- the determination to preserve the methods of the artisans who had handed down a shop's tradition
- the individual's ambition to make a name in the city, to be honoured among fellow craftsmen, and to receive good wages for labour
- the unified artistic control exercised by the master of a shop.
 (Feldman, 1982, p. 63)

These classical legacies continued to guide artistic expression throughout medieval times. European guilds strongly resembled the artisan brotherhoods of ancient Greece and Rome. Craft work bore the stamp of the guild which produced it, not the signature of the artisan who made it. By the close of the premodernist era, however, the status of the craftsperson had significantly improved, and although guild masters seemed preoccupied with standardizing production practices, regulating trade procedures, and reducing sources of potential competition, they had encouraged a concept which was to usher in the modernist era: the quality of an object was directly related to the qualities of the person who made it.

■ Modernist Paradigm

The theocentric foundation of premodernist art was replaced during the renaissance, romantic, and existentialist phases of humanism by a new Western conception of the artist. Instead of attempting to mimic, or reflect, a universe created by the Almighty, Western artists assumed the role of inventor. Thus, the modernist paradigm is oriented towards production, rather than replication. Metaphorically speaking, Kearney refers to the modernist paradigm as a lamp - the proverbial lamp of learning illuminating the way, so to speak.

Artists during this era increasingly associated themselves with humanist intellectuals, primarily philosophers, mathematicians, and scientists. This new artistic environment resulted in two dramatic departures from medieval art. The first involved a fascination, almost obsession, with nature; the second with the development of linear and aerial perspective:

> Late medieval art, encouraged by the preaching of St. Francis, had already opened its eyes to nature. As earthly existence slowly improved, the representation of living creatures could be undertaken with less fear and guilt...once Renaissance painters had built the illusion of deep space, they could populate that space with every sort of creature, object, or growing thing. The floodgates were open; even nudes were now possible. (Feldman, 1982, p. 91)

Medieval artists had concentrated their efforts on the attainment of technical mastery over materials: wood, stone, glass, cloth, and paint. Compositional designs were based upon theological concepts, such as numerology and iconography: the *number* of adoring saints, the *colour* of their robes, their horizontal *placement* relative to Christ - all such artistic problems found their resolution in the divinely-inspired, inerrant Word of God.

In contrast, humanist artists concentrated their efforts on the attainment of intellectual mastery over ideals: beauty, truth, nature, space, and proportion. Compositional designs were based upon rational concepts:

> When studying anatomy, perspective, and geometry, the artist made logical connections with classical philosophy and natural science. The connections between mathematics and perspective, anatomy and sculpture were clear. As for Beauty - the supreme ideal of Renaissance art - it depended on harmonious, that is, mathematical, relationships. Those relationships were embodied in the laws of design - Vasari's *disegno* again. And the laws of design, said Vasari, originate in the intellect. (Feldman, 1982, p. 90)

Modernism sought to free mankind by controlling the heavens, the natural world, and the human mind. Its repeated failure to produce freedom through control inspired a new emancipatory paradigm - postmodernism.

■ **Postmodernist Paradigm**

In Kearney's postmodernist paradigm, the Western conception of the artist is that of a *bricoleur*, or collagist. No longer restricted by formalist conventions and modernist universals, artists rely on allegories, metaphors, and narrative elements to create art that essentially parodies contemporary culture. The root metaphor for this paradigm, a labyrinth of looking glasses, goes beyond the mimetic mirror metaphor of premodernist art:

> What is reflected is not the outer world of nature or the inner
> world of subjectivity, but a complex maze of associated
> meanings - the mirror's reflection of itself into infinity. The
> artist has become a fun-house mirror anonymously parodying,
> simulating, or reproducing images. (Pearse, 1992a, p. 249)

This paradigm-in-progress has already transformed many modernist notions of art, artists, and the art world.

First, in terms of art, the modernist concepts of originality-as-process and originality-as-product have been swept aside. Postmodernists deny the existence of singular founding references or points-of-departure; instead, they speak of signifiers and deconstructed meanings which produce an infinite array of interrelated and circular interpretations. There are no original ideas in art; images can always be deconstructed to reveal antecedent constructs and concepts. The value placed by modernists on authentic originals has also lost much of its currency. Postmodernist art more often than not takes the form of mass-produced images or multiple series made possible by state-of-the-art reproductive technologies. This heavy reliance upon computer and video imagery has resulted in two further departures from modernist art:

■ Distinctions made between high art *versus* low art and fine art *versus* craft have simply lost their relevancy.

■ The postmodernist preference for recognizable imagery has allowed artists to speak directly with segments of society formerly alienated by the elitist cast of modernism.

Second, in relation to artists, the myth of heroic artistic genius was an early casualty in the war waged by critical theorists on modernist art. The White, male hero was toppled from his pedestal as the originator of artistic meaning and relegated to an intermediary role as a cultural producer, signalling a return to artistic production reminiscent of the artisan brotherhoods of ancient Greece and Rome and the guilds of medieval Europe:

> The postmodern construct views the artist as cultural producer,
> and the work of art as a dialectical catalyst, a beginning rather
> than a monument...Before as well as after a work is finished,
> the artist is less central to its production than the Western
> humanistic concept of the artist implies, even as bearer of the
> artwork's meaning. (Fehr, 1994, p. 210)

The demystification of the artistic process has been another contribution made by critical theorists to postmodernist art. Rather than considered the result of a solitary man making brilliant leaps into previously unknown territory, the creation of art is now seen as a collective enterprise:

> Someone educates the artist, someone makes the artist's materials, someone criticizes the work, someone places it in its historical context, someone sells the work, and someone buys it. (Fehr, 1994, p. 210)

These more expansive conceptions of the artist and the artistic process have encouraged a greater level of participation in the art world by marginalized members of Western society. Such artists have had to decide, however, whether to join the mainstream or establish their own creative spheres. In making their decision, most minority artists have had to first define their own artistic sensibilities, senses of self, and voices; only then were they able to determine whether their creative energies would be best exercised working alongside, or separated from, the mainstream. This dilemma will be discussed at further length in Chapter 2.

Third, the art world has also been significantly transformed by postmodernism. Just as the iconography surrounding contemporary notions of the artist has been expanded through the participation of marginalized groups, the art world has also expanded through an increased appreciation for non-Western artworks. Even the most xenophobic factions within discipline-based art education have acknowledged the educational value of including content and exemplars from Asia and Africa in school art curricula.

Postmodernism has affected the art world on a less-global scale, as well, for its creative pulse has moved beyond the museum door into the street. Through its commodification of art and manipulation of technological imagery, postmodernism has placed the media at the epicentre of the contemporary art world: "We depend on the media as intercessory...Today an artist's work may have no meaning, for all intents and purposes, until it is blessed by the media" (Fehr, 1994, p. 211). This translocation of power within the art community has generated substantial criticism from those who lament the demise of formalism which, for all its well-documented shortcomings, did provide the art world with standards of a sort:

> The most vocal critics, however, have targeted the art establishment as a primary source of concern, the proliferation of dealers who select work based on what is marketable rather than what is good, fostering the idea that art is a commodity, and the museums with their corporately-financed extravaganzas, exhibiting work that is pleasing to the eye, but devoid of anything controversial or particularly thought-provoking. (Parks, 1989, p. 12)

In this final section of Chapter 1, we have been examining what the postmodernist attribute of deliberate ambivalence means for us as art educators. We began by exploring the pedagogic ambivalence that has developed between instrumentalist and essentialist curricula in elementary and secondary schools. We subsequently considered the cognitive ambivalence which has characterized empirical-analytic, interpretive-hermeneutic, and critical-theoretic forms of knowing in art education. We concluded by looking at the creative ambivalence which has emerged from mimetic, productive, and parodic Western conceptions of the artist.

In Chapter 2 we will be listening to the voices of postmodernism, voices which speak to the additional attributes of diversity and difference.

2 Diversity and Difference

The first goal of a feminist art education may be labelled an
education to diversity and difference.
By this I mean that art education should be geared to increasing
students' knowledge and awareness of their own cultural
backgrounds as well as of the multiplicity of diverse traditions
which together constitute our society and our world.

Laurie Hicks

In this chapter we will be listening to voices which speak to the
postmodernist concepts of diversity and difference. The voices belong to
individuals and groups long marginalized in modernism's White, male universe
of urban *chic*: women, people of colour, ethnic minorities, gays and lesbians,
the physically-challenged, non-urbanites, and those living anywhere in poverty.
If this list seems excessive, although it is by no means exhaustive, it should
serve to underscore how restrictive modernism's notion of universality really has
been.

Given the breadth and depth of marginalization experienced by
modernism's minorities, it should come as no surprise that the literature on
postmodernism is both extensive and varied. In this chapter, however, our
discussions will be primarily focused upon those voices within art education
which address feminist and multicultural concerns.

The need to transform art education into a more inclusive field of study
is no longer being questioned in the literature; instead, various positions are
being posited as to the nature of inclusivity and empowerment. Fundamental to
this discourse is the postmodernist concept of community. Laurie Hicks paints
Elliot Eisner (1987) and Hannah Arendt (1986) as proponents of inclusion
through assimilation, that is to say, of a homogeneous *community of sameness*:

If, like Eisner and Arendt, we seek to promote a homogeneous
community of sameness, our goal will be to eliminate or
marginalize the particularities which make us differ, and focus
on an educational process that will promote those abilities and
characteristics that are generalizable. To succeed here would
be to empower students, that is, to free them from difference
and free them to assimilate. (Hicks, 1990, p. 43)

Perhaps the most obvious example of this approach to greater inclusivity within our field is discipline-based art education (DBAE). Proponents of DBAE have responded to claims of marginalization by:

- including non-Western exemplars
- acknowledging non-Western aesthetic sensibilities
- emphasizing those elements common to Western and non-Western art.

Such assimilationist responses, however, have been routinely rejected by postmodernist scholars working within and beyond the field of art education. Critics maintain that assimilationist curricula merely camouflage systemic discrimination and perpetuate social inequities through cultural co-option: "Lyotard suggests that men intended to draw women into their professional communities and, in the process, re-create women to be more like men" (Freedman, 1994b, p. 157).

Instead, postmodernists such as Iris Marion Young (1990) and Seyla Benhabib (1987) have advocated a heterogeneous *community of difference*:

On the other hand, if, like Young and Benhabib, our goal is a society which does not marginalize difference and give it unequal status, then empowerment must be a process that facilitates the strengthening of local particularities, minority traditions, and eclecticism. Empowerment with this goal would free students from dependence on mainstream values and commitments while freeing them to question, look, and create critically in any number of different traditions. (Hicks, 1990, p. 43)

Even within the discipline of anthropology the usefulness of *difference* as a paradigmatic theme and *culture* as a conceptual framework is under attack. Citing various examples of an ongoing interdependence between aboriginal and EuroCanadian art during prehistoric and contemporary periods, Canadian anthropologist Joan Vastokas (1996) has suggested that the modernist dualisms which divided aboriginal from EuroCanadian cultures be replaced by a "global web of interconnected constellations of individuals and groups of individuals."

Thus, the postmodernist concepts of diversity and difference stand in stark contrast to the modernist tenets of commonality and similarity. For art educators wishing an alternative to assimilationist responses to the voices of marginalization, Elizabeth Garber (1990) offers the following *conversationalist* approach:

Patrocinio Schweickart (1985) proposes a "conversation" between pluralisms. The aim of the conversation is comprehension, not agreement. Schweickart seeks coherence, though this need not be bound by consistency and uniformity. Within the art education classroom, the goal of art criticism becomes coherence in diversity and respect, rather than a unity of logical consistency." (p. 22)

2.1 Feminism

We value particularity and individuality
in art and in teaching.
Now we need to value particularity and individuality
in women as heartily as we value them in men.

Elizabeth Sacca

Although postmodernist constructs such as *community of difference* and *conversations between pluralisms* find their warrant in feminist scholarship, it is important to remember that not all feminist theory is postmodernist; indeed, early feminist research operated within decidedly modernist parameters. Thus, we need to conceptualize feminism as a theoretical continuum along which specific research emphases can be situated. At one end, we can locate feminist theories which are predominantly modernist; at the other, we can place those theories which are essentially postmodernist. Predictably, the majority of feminist theories can be fixed somewhere between these theoretical poles, reflecting both modernist and postmodernist concerns.

For an example of feminism's transitional nature we can turn to a 1995 article by Georgia Collins entitled, "Explanations owed my sister: A reconsideration of feminism in art education." Within her writing Collins acknowledges her own privileged position as an able-bodied, White, Western, middle-class, heterosexual female and she adopts a typically postmodernist posture:

> In our efforts to discover and make heard our own voices, it
> is all too likely that we have ignored or silenced voices of
> other, variously different, marginalized sisters and brothers
> with experiences not entirely unlike but certainly not identical
> with our own. (p. 76)

Collins worries, however, that she is unable to understand and be understood by her own sister who is also White, middle-class, aging, and educated:

> How can I hope to converse with sisters and brothers who
> have had radically different experiences from mine, who have
> been oppressed not only on account of gender, but on the basis
> of other types of difference: age, race, economic class, sexual
> orientation, ethnic origin, and physical, mental, or emotional
> "enabledness"? (p. 80)

Despite these overtly postmodernist passages, Collins' writing frequently reveals her lingering modernist roots. For example, when citing a 1990 survey of art education programmes in higher education, which suggests that female graduate students outnumber their male counterparts by a three to one margin, Collins fails to register any concern about gender imbalance. At the same time, however, Collins continues to speak at length about unequal pay, hiring, and promotion practices which treat women unfairly.

Similarly, feminist critics have drawn attention to the paucity of female administrators within the education system, notably at the elementary school level, despite the numerical dominance of female teachers. Calls have also been made for proactive interventions designed to increase the proportion of female students studying advanced computer studies, mathematics, and science.

At first glance, such criticisms have appeared to be beyond reproach; upon further reflection, however, it has become apparent that the high moral ground claimed by feminist researchers has not always been justified. Feminists have often failed to acknowledge that modernist gender stereotypes and role definitions served men as badly as women, although admittedly in different ways. Certainly, rates of male incarceration, addiction, suicide, violence, and premature death belie the modernist feminist contention that the world was created by men for men.

Postmodernist feminist scholarship does not employ modernist binaries such as aggressor/victim, powerful/helpless, violent/passive, abusive/nurturing, which invariably assigned the former factor to males and the latter to females. Such pairings have been uncoupled and reconceptualized as non-biologically determined sociological conditions which characterize both men and women:

> A woman's perspective is not biologically predetermined or
> universal, nor is it morally superior to the perspectives of
> men. (Irwin, 1995, p. 155)

Thus, modernist feminist concerns about gender imbalance within education have been extended to include situations where men are poorly represented, such as:

- male educators teaching in primary grades
- male students selecting family studies.

Feminist research in art education has traditionally lagged behind scholarship within other disciplines. Prior to 1977, only one article published in *Studies in Art Education* dealt with male/female differences and, despite a special issue devoted to such research in 1977, by 1987 only eight additional articles had been published within 32 ensuing issues (Sacca, 1989).

This lag continues in the 1990s. Although postmodernist perspectives have found wide acceptance within feminism-as-a-whole, feminist art educators have been reluctant to abandon their modernist belief in progressive change which has slowed the development of postmodernist scholarship within our field:

> We are bound to be ambivalent about postmodernism, however, because it takes from us a modernist optimism about our *own* ability to change things, calling attention to the violence we ourselves are capable of doing in the name of so-called universal ideals. (Collins, 1995, p. 78)

Nonetheless, sufficient movement towards postmodernist conceptions of reality and the construction of meaning has been made to suggest that feminist research within art education has entered a second generation (Hagaman, 1990). We can, therefore, structure this overview of feminist literature within art education into two segments: first generation, and second generation scholarship.

■ First Generation Scholarship

From the outset, feminist critics focused their research on three allied but distinct strands: social analysis, political activism, and self-knowledge (Garber, 1990). In the first, analytic feminist scholars examined social and cultural phenomena which they perceived to negatively affected women, such as gender-differentiated patterns of schooling and maternally-related restrictions upon career access and advancement. Activist feminists centred their work in local and national political arenas, building mutually advantageous linkages with unionist and religious organizations. Women-centred feminists contributed by proposing alternatives to existing patriarchal systems, such as qualitative research and pedagogies based on cooperation and nurturance.

First generation feminist scholarship in art education reflected all three of these research strands. Working within an essentially modernist social and political milieu, such scholarship attempted to:

- add *lost women* and their accomplishments to existing Western canon
- promote a greater recognition of women within the profession
- expose the patriarchal nature of female imagery in Western art
- explore the basic characteristics of feminine aesthetic sensibility.

■ Adding to Existing Western Canon

One of the earliest, and easiest, targets for feminist criticism was the absence of women artists and female-dominated art forms in the art history texts studied by most art educators, such as: *A Basic History of Art* (Janson, 1986), *Art: The Way It Is* (Richardson, 1980), *Arts & Ideas* (Fleming, 1991), *Discovering Art History* (Brommer, 1981), *The Story of Art* (Gombrich, 1989), and *Varieties of Visual Experience* (Feldman, 1987).

This phenomenon can be clearly seen in Edmund Burke Feldman's text *The Artist* (1982). In the twelfth and final chapter, entitled "The Hyphenated Artist," women artists are accorded a grand total of seven brief paragraphs - paragraphs which they are incongruently forced to share with ethnic artists. Feldman readily acknowledges the marginalization of women artists throughout Western history, but maintains that:

> Hyphenation becomes part of a vicious circle [that is] ultimately self-defeating as a professional strategy for the artist. Nevertheless, there have been some gains due to hyphenation. The art world has been obliged to recognize the distinctive artistic values that grow out of the experience of being a woman. (p. 206)

Obliged or otherwise, our levels of awareness of and knowledge about women artists have been significantly raised by ground-breaking texts such as: *Dictionary of Women Artists* (Pettys, 1985); *Women and Art: A History of Women Painters and Sculptors from the Renaissance to the 20th Century* (Fine, 1978); *Women Artists: An Historical, Contemporary, and Feminist Bibliography* (Bachmann & Piland, 1978); *Women Artists in History* (Slatkin, 1990); and *Women, Art and Education* (Collins & Sandell, 1984).

Despite such visible signs of attitudinal change, research undertaken by feminist art historians to rediscover significant women artists of the past demonstrated that women artists cannot easily gain prominence in overtly patriarchal cultures, past or present:

> It should not be surprising that art education is as sexist as the society in which it exists. Nor is it as sacrilegious as some might think to propose that art education is any way open to intervention by political and social interests. (Wolff, 1990, p. 203)

In some cases, research revealed that women artists gained their access to materials and training due to aristocratic status or relation to practising male artists. In many jurisdictions the pace of progress remained agonizingly slow. For example, in 1986 the Ontario *Visual Arts Guideline: Intermediate and Senior Divisions* mandated the study of 120 master art works, a canon which involved not a single Canadian and only one female artist (Hall, 1993).

■ **Increasing Professional Recognition**

An additional goal of first generation feminist scholarship was greater career access and advancement for women within art education. At first glance, men certainly appear to have dominated the field for most of this century: Manuel Barkan, Kenneth Beittel, Graeme Chalmers, Arthur Wesley Dow, David Ecker, Arthur Efland, Elliot Eisner, Charles Gaitskell, Arthur Lismer, Viktor Lowenfeld, Ronald MacGregor, Kenneth Marantz, and Walter Smith.

Since the 1960s, however, women have played increasingly equal roles in the field. Laura Chapman, June McFee, Elizabeth Sacca, and Leah Sherman led the way for more contemporary female art educators, such as Georgia Collins, Kerry Freedman, Elizabeth Garber, Karen Hamblen, Rita Irwin, Diana Korzenik, Cathy Mullen, Renee Sandell, Mary Ann Stankiewicz, Patricia Stuhr, and Enid Zimmerman. By the 1990s, gender parity had been achieved in:

- professional organizations, such as the National Art Education Association and the Canadian Society for Education through Art
- professional publications, such as *Studies in Art Education, Art Education, Canadian Review of Art Education,* and *Journal of the Canadian Society for Education through Art*
- graduate education, especially at the doctoral level where women outnumber men.

This aspect of feminist scholarship has produced a body of literature focused on gender-differentiated patterns of schooling and styles of leadership. It is interesting to note that significant contributions have been made in these two areas by male art education historians, such as Graeme Chalmers (1990, 1993), Peter Smith (1988), and Don Soucy (1989, 1990).

In regard to patterns of schooling, considerable attention has been devoted in the literature to three turn-of-the-century British models of art education. In the first, training in the applied and decorative arts was available to lower- and middle-class women in the South Kensington Schools, a state-sponsored system of art schools founded in the 1850s to prepare artisans and teaching masters. In the second model, training in the fine arts was provided at academies, the most prestigious of which was the Royal Art Academy. While these art universities did admit women, they did so under unequal conditions:

Women who attempted to study at academies, exemplified by the Royal Art Academy model, often were seen as lesser talents, separate but unequal in terms of their intellectual and technical abilities. This was not as true for women studying at the decorative arts schools where they worked and competed more equally with men and where their labor, in specific areas, was needed to build England's economy. (Zimmerman, 1991, p. 110)

Ironically, although both of these institutions claimed to be dedicated to raising standards for British art and design, they were equally criticized for producing uninspired and stylized art. Their contemporary counterparts, the Bauhaus and university fine arts models, have similarly been accused of curricular rigidity, especially by postmodernists who reject the male artist as genius mythology which pervades current studio education (Wainio, 1995). The third model involved private ladies' schools which provided opportunities for upper-class women to pursue artistic handicrafts as a means of self-improvement and cultural refinement.

Such historical research into British models of art education contributed to feminist scholarship by:

- providing comparative models of secondary, college, and university art education similar to those in Canada and the United States
- demonstrating how the issue of career access differs from the concept of career equity
- illustrating the need to consider a range of related sociological factors, such as economic class, while conducting feminist research.

First generation feminist scholars also relied heavily upon historical research to explore how gender affects career advancement, the development of leadership style, and the attainment of lasting status in art education. These three career characteristics - advancement, leadership, status - provided the cornerstones for studies by Mary Erickson (1979), Mary Ann Stankiewicz (1982), and Peter Smith (1988) which sought to explain the nascent condition of art education and the descent into obscurity of formerly prominent female university art educators, such as Alice Robinson of Ohio State and Jane Betsey Welling of Wayne State.

Erickson postulated that art educators' personal and professional self-images play important roles in the advancement of individual careers and in the development of the field itself. Alice Robinson was cited as an educator with a sexist image of herself who limited her career accomplishments by:

- failing to separate her personal and professional lives
- remaining single and exhibiting *old maid* personality traits
- acquiring little professional power or recognition
- viewing herself primarily as an artist and art historian
- considering studio work to be more important than academic study
- believing that art teachers were born, not made
- emphasizing how to make art rather than how to teach art.

Jane Betsey Welling shared virtually none of these stereotypical female artist-teacher characteristics but nonetheless failed to attain lasting recognition in the field. Smith accounts for Welling's current obscurity by pointing to her failure to present any powerful new ideas, remaining forever faithful to her Dow-Dewey background.

These biographical studies have contributed to feminist scholarship in art education by demonstrating the negative effects of internal sexism and the need to consider factors in addition to gender when dealing with female career advancement, such as securing a university post which offers graduate studies, gaining the attention of former students interested in historical research, and possessing a charismatic personality which intrigues students. Canadian art educator Rita Irwin (1991, 1995) has undertaken considerable research into the nature of charismatic leadership and suggests that charismatic leaders are distinguished by their ability to demonstrate vision, communicate vision, build trust and commitment, and empower others.

■ **Exposing Patriarchal Female Imagery**

First generation feminist scholars also devoted considerable attention to the prevalence of patriarchal female imagery in art, books, and entertainment. The poststructuralist concept of the *male gaze*, which refers to the subject/object and artist/model polarities that exist within Western art, was frequently used by feminists to draw attention to an insidious form of artistic oppression:

> The male gaze works as a mechanism of oppression as it elevates males to the status of privileged spectators (Devereaux, 1990; Kaplan, 1986). Feminists respond that treating people as objects of aesthetic contemplation is dehumanizing and call for a revised aesthetic, attentive to and respectful of differences among gendered spectators. (Garber, 1992, p. 213)

The male gaze, therefore, encompasses much more than the traditional reclining female nude; rather, it involves the deeply-entrenched, systemic assumption within Western culture that the *male experience* is both universal and normative, worthy of consistently and singularly providing the subjective vantage point for visual expression.

Perhaps even more oppressive than the objectification of female imagery in art, however, has been the traditional use of male terminology in books and spoken language. For, while the male gaze assigned a position of objectified inferiority to women, male terminology oppressed more completely by subsuming women entirely: *mankind* covered everybody. Significant progress has been made in this area during the past two decades; notice how clearly inappropriate the exclusive use of masculine pronouns in the following passage, published in 1980, appears to us today:

> The teacher's role fluctuates according to the needs of the students. He plans learning experiences in which the students have to work individually, seeking out knowledge on their own; and he designs other activities where students join with others to carry out a task and where discovery through action is attempted. The teacher is, therefore, not an interpreter, director or controller. Rather, at different times within the same lesson, he can be an advisor, a consultant, a questioner, or a sounding board. Even, at times, he can be a guide. (Courtney, 1980, p. 76)

Contemporary writers and editors strive to avoid patriarchal female imagery in books by: employing gender-neutral or gender-balanced pronouns; avoiding generic words with masculine markers *(mankind)*; replacing gender-designated occupational terminology *(chairman, waitress)*; removing sex-role stereotypes; and including positive references to motherhood, fatherhood, and domestic relationships (Turner, 1990).

No discussion of patriarchal female imagery can be complete without some reference to pornography, and this brief overview will prove no exception. Given the centrality of the human form within artistic expression it may come as a surprise, however, to learn that pornography has seldom been addressed by art educators in recent years (Blandy & Congdon, 1990; Gracyk, 1987).

Certainly, pornography has proven to be one of the most universal and enduring themes in the history of art. From the *Venus of Willendorf*, mythical acts of bestial copulation painted on Greek urns, to explicit *how-to* illustrations recently excavated inside bordellos in Pompeii, women appear to have been the object of sexual exploitation since earliest times. To find more contemporary examples of pornographic imagery, however, art educators apparently only need to look at recent issues of *Art Education*:

> Every issue of *Art Education* for several years has included a supplement of four-colour reproductions, usually of paintings, and a lesson plan for each. Many of the art works chosen could easily be considered by some viewers as disturbingly destructive to women...The lesson plans accompanying these reproductions do not treat the passivity and degradation with any degree of specificity or the possibility that these works might be examples of social criticism about the treatment of women. (Blandy & Congdon, 1990, p. 8)

To substantiate their claim of pornography within our professional literature, Doug Blandy and Kristin Congdon offered the following examples:

- *Into the World There Came a Soul Called Ida*
 by Ivan Albright, 1929-30 (Sousa, 1987)
 Sousa's lesson ideas, prepared for students in grades 10-12, were criticized for not challenging viewers to consider the cultural or personal values embedded within the model-as-vanity symbolism.
- *The Nightmare*
 by Henry Fuseli, 1781 (Shannon, 1986)
 Designed for students in grades 7-9, Shannon's lessons were challenged for their use of sexist language and depiction of female subordination to a mythical beast.
- *Marilyn Monroe*
 by Willem De Kooning, 1954 (Nelson, 1988)
 Nelson's lesson plan, suggested for use in grades 7-9, was questioned by Blandy and Congdon for failing to draw attention to the exploitative relationships between the artist and his model, and between the actor and her publicity agents.

From these examples it is clear that first generation feminists attempted to broaden our concept of pornography beyond its traditional domain of overt sexual activity to include forms of female subordination to men. Do Blandy and Congdon's examples advance or discredit this new definition of pornography?

■ **Exploring Feminine Aesthetic Sensibility**

First generation feminists also searched for evidence of a feminine aesthetic sensibility distinct from masculine Western aesthetic ideals. Such research may seem incongruent with feminist claims to equality, since the notion that women were biologically unable to create great works of art had been long used to keep women in positions of artistic inferiority (Zimmerman, 1991):

> Academic studies do much for men, but it is doubtful if they are ever very useful to women of first rate ability...[Women do] their best work...intuitively under instinctive rather than technical guidance. (Sparrow, 1900, p. 176)

Women painters were praised for "spontaneous, efflorescence of imagination, religion, and love of beauty" (Caw, 1900, p. 148) and "great minuteness and accuracy of detail...feminine keenness of observation" (Hagan, 1898, p. 95).

The role of biological determinacy within creativity was an avenue of research also pursued by developmental psychologists, a group of remarkably uncreative individuals revered by Lowenfeldian art educators. It found its widest acceptance, however, within Freudian psychoanalysis (Erikson, 1963):

> If "high" and "low" are masculine variables, "open" and "closed" are feminine modalities. Interiors of houses without walls were built by a majority of girls. In many cases the interiors were expressly peaceful. (pp. 103-104)
>
> Simple enclosures with low walls and without ornaments were the largest item among the configurations built by girls. However, these enclosures often had an elaborate gate, the only configuration which girls cared to construct and to ornament richly. A blocking of the entrance or a thickening of the walls could on further study be shown to reflect acute anxiety over the feminine side. (p. 105)

As expected, the alleged tendency of boys to build high towers and girls low gates was tied to Freudian theories of psychosexual development:

> The spatial tendencies governing these constructions are reminiscent of the *genital modes*...and...closely parallel the morphology of the sex organs. (p. 106)

Nonetheless, several feminist scholars put forward the proposition that a *gynecentric aesthetic* (Ecker, 1985; Langer, 1982) really did exist. Lauren Rabinovitz (1980/1981) developed the concept further by offering some specific characteristics that such a women-centred aesthetic would possess. According to Rabinovitz, great works of art created by women would:

■ encourage active viewer participation
■ include traditional women's crafts
■ use female imagery without objectification or misappropriation
■ involve cooperation among artists of equal status.

▪ Second Generation Scholarship

Whereas voices within first generation feminist scholarship spoke frequently in terms of gender superiority, voices within second generation scholarship speak primarily in terms of gender equality:

> Admittedly there are many feminists who call for an extreme feminine perspective, believing that the female viewpoint is superior to the male viewpoint. Much of the literature of the sixties and seventies in feminist scholarship certainly pointed to this end. However, since some of the dust has settled, feminists of the eighties and nineties speak from a less aggravated spot and are urging for a standard that is based on equality and fairness. (Van Reeuwyk, 1990, p. 104)

Having convincingly demonstrated how gender affects the canon of disciplines, career access and advancement, and organizational leadership, feminist scholars now find themselves presented with a new set of questions needing resolution:

▪ *Can male-dominated disciplines be sufficiently reformed to accommodate female ways of knowing and interacting?*

▪ *Are gender-based differences biologically determined or are they socially constructed?*

▪ *What are the implications of feminist research for the field of education?*

▪ Reforming the Disciplines

In spite of the success experienced by early feminists in adding *lost women* and their accomplishments to existing Western canon and promoting women within traditionally male-dominated professions, many second generation scholars have called for the thorough reconstruction of disciplines to provide fundamental epistemological equality. Experience has convinced many feminists that internal reconstruction is necessary since attempts at external modification produced only superficial change within most academic disciplines. Not willing to accept political co-option as *honorary men*, second generation feminists have instead offered concrete alternatives to the status quo.

First, working within predominantly postmodernist paradigms, they have systematically deconstructed traditional academic disciplines to reveal how superstructural elements work through social channels to the advantage of White males and, through exclusionary content and practices, to the detriment of virtually everybody else.

Second, having revealed the socially-constructed nature of most forms of knowledge, feminists have reconstructed the disciplines to accommodate individuals and groups marginalized by traditional epistemological boundaries.

In Chapter 1 we discussed in some detail how postmodernist scholars have deconstructed the superstructures embedded within modernist art by:

- debunking the fraudulent image of the artist as male genius
- exposing the male artist/female model syndrome
- rejecting the universality of male experience
- repudiating the concept of originality
- questioning the supremacy of form over meaning
- challenging the equation of change with progress
- contesting the distinctions made between art and craft.

Characterizing modernist art as a homogeneous *community of sameness*, feminist critical theorists have reconstructed the discipline into a heterogeneous *community of difference*. Arguing that societies are comprised of diverse groups with competing interests that exist in a state of constant tension, feminists have contended that groups are held together by networks of power and domination. As a socially-constructed activity, art plays an important role in such conflicts:

> Art works are not benign messages but sites of ideological
> conflict in which competing groups impose meaning upon
> artifacts in an attempt to impose a direction on further thought
> and action. Artworks are battlegrounds for consciousness.
> (Duncum, 1991, p. 51)

Feminist art educators have given curricular expression to the concept of art as a community of difference by developing new approaches to teaching art. Drawing heavily upon historical and ethnographic inquiry methodologies, feminist art curricula:

- value non-Western forms of artistic expression
- place artists within relevant time, experience, and cultural contexts
- present art history in non-linear, non-progressive paradigms
- accord equal status to non-formalist criteria for art criticism
- use cooperative, collaborative, nurturing pedagogies (Hagaman, 1990).

■ The Nature of Gender Difference

Perhaps nowhere has the evolution between first and second generation feminist scholarship been greater than in research into the nature of gender difference. In this area feminists have wrestled with two underlying issues. First, they have attempted to ascertain whether individuals are essentially masculine, feminine, or both. Note that the preceding sentence did not use the deceptively similar terms male or female, which denote biological aspects of gender. This distinction is important because feminist research into the nature of gender difference has not been about sexual orientation - straight, gay/lesbian, or bisexual - but about gender self-identification and sensitivity to others. Second, feminists have tried to determine whether aspects of gender difference are biologically or sociologically determined.

To support their contention that individuals are essentially masculine and feminine, Elizabeth Garber and Yvonne Gaudelius have drawn attention to the concept of *l'écriture féminine* developed by French linguist Hélène Cixous. At the heart of this feminist construct is a psycho-bisexuality which allows men such as James Joyce to write *feminine* texts and women to write *masculine* texts:

> [There are] female writers...the immense majority whose work is in no way different from male writing, and which either obscures women or reproduces the classic representations of women. (Cixous, 1981, p. 248)

Cixous' model, however, retains the element of female superiority prevalent in early feminist scholarship by maintaining that:

> A masculine libidinal economy...is based on exchange and the desire to possess. In contrast to this, a feminine libidinal economy derives its strength from [sexual] pleasure. Within a masculine libidinal economy difference comes to mean hierarchy. Cixous suggests that within a feminine libidinal economy it may be possible for individuals to be equal and different. (Garber & Gaudelius, 1992, p. 16)

A consensus has emerged in the literature (Burgin, 1982; Garber, 1992; Hagaman, 1990; Irwin, 1995; Kelly, 1982; Sacca, 1989; Waugh, 1990) that:

- there is no pre-existing sexuality, feminine sensibility, or biologically determined femininity
- traditional notions of gender difference define and delineate a limited range of options for women
- traditional gender differences can be socially deconstructed to foster equality between men and women.
- new concepts, such as *l'écriture féminine*, need to be developed as alternatives to traditional notions of gender difference.

As a result of such evolving views on gender difference, the modernist male/female dichotomy which invariably presented women as victims of male aggression has lost considerable ground in recent years. Previously unthinkable questions have begun to appear in print:

- *Can women produce pornographic works?* (Blandy & Congdon, 1990; Heartney, 1988)
- *Is there a female gaze?* (Garber, 1992; Kaplan, 1986).

Typically, modernist feminists have reacted to what they consider heretical propositions by maintaining that women are incapable of assuming the role of privileged spectators and objectifying men. As victims of male aggression, women simply do not have the power to effectively oppress men. Similarly, Black activists have denied the possibility that Afro-Americans can be racist. As women and other marginalized groups continue to acquire greater levels of power and influence within Western society, such modernist concepts of gender difference are likely to come under ever-increasing scrutiny.

■ **Implications for Education**

In his article "An art education for the 2020s: One that is truly moral" Ted Bracey (1990) has predicted that the marginalization of women, minorities, and the poor will reach a point of crisis early in the new century, and that art educators who attempt to avoid such a calamity by merely accommodating the artistic cultural capital of minority groups will be unsuccessful:

> What they will ultimately have to accept, however, is that these aims and objectives will be largely defeated while they continue to assign unconditionally positive value to individuality, innovation, divergence and independence, etc., in artistic practice, while assigning negative value to tradition, convergence, group dependence and imitation, values which, in other class cultures, are regarded as being positive. (p. 42)

Female children, in particular, experience considerable internal conflict from contemporary art curricula which require assertive, material, and competitive forms of studio production, abrasive behaviours which contrast sharply with the socially-constructed feminine values of caring and nurturing.

In response to the masculine orientation of modernist art academies, first generation feminists frequently sought refuge in women-centred educational environments. Barbara Huber (1990) has documented the mentor programme developed by the Manitoba Artists for Women's Art (MAWA) collective which paired emerging and established female artists, as well as the Womanhouse Project in California:

> There were no fixed authoritative rules. Classes were held in a circle to emphasize equality and democratic participation. Each person was responsible for contributing from her own life and knowledge because the "personal as political", incorporated as a central philosophy, stressed theory developed from the affirmation of individual experience. Dealing with difficulties in the personal or private sphere was seen as integral to learning and not separate. And, finally, what had formerly been considered trivial subject matter in art training (anything to do with being female in the world), became acceptable content for art. (pp. 77-78)

Although some feminists continue to advocate segregationist solutions, second generation feminists have sought ways to effectively maintain such women-centred pedagogies within co-educational settings. Other marginalized groups, such as Afro-Americans and gays/lesbians, have faced similar educational dilemmas, and in the next section we will take a closer look at a wide range of alternative strategies developed by educators working within the field of multiculturalism.

2.2 Multiculturalism

It is imperative that teachers and students
begin to choose curriculum content from the local community
that is both culturally relevant
and has the potential to provoke social and critical inquiry.
This is the challenge of multicultural art education.

Patricia Stuhr, Lois Petrovich-Mwaniki, and Robyn Wasson

Along with conceptual frameworks derived from feminist scholarship, critical theory related to multiculturalism has contributed considerably to the body of postmodernist literature within art education.

As with postmodernism, the term multiculturalism has gained currency in recent years because of its communicative elasticity. In the United States, multiculturalism has frequently replaced postcolonial criticism as a less-confrontational rubric for the study of race relations, however, multiculturalism should not be equated to issues of only race. According to Banks & Banks (1993) references to multiculturalism may involve one or more of the following allied but disparate phenomena:

- an idea or concept
- an educational reform movement
- a process.

Proponents of multicultural education maintain that all students should have equal learning opportunities regardless of gender, class, ethnic, racial, or cultural characteristics.

Our discussion of multiculturalism within art education will begin with an historical overview, followed by a survey of curricular approaches currently being advocated within the profession. In order to give additional emphasis to the diversity of research perspectives that exists within the literature on multiculturalism, the voices of three minority groups will be highlighted:

- Black
- gay/lesbian
- Native.

■ Historical Overview

In the United States, the history of multiculturalism can be traced back to the Americanization movement of the 1880s (Billings, 1995). Acquiring the more vernacular title of *the melting pot* during the 1890s, the movement sought to promote social harmony through the creation of a homogeneous, uniquely American culture. By the First World War, the essentially assimilationist melting pot approach to social rapprochement between established and newly-arrived minority groups came under increasing attack from critics promoting an alternative strategy - cultural pluralism. Proponents of cultural pluralism, many of whom held positions of leadership within the Progressive educational movement of the 1920s, maintained that:

- ■ benefits obtained from a culturally diverse society would consistently exceed those derived from a culturally uniform society
- ■ variations in power among disparate minority groups would be less problematic within the framework of a heterogeneous culture.

It is important to note, however, that the diversity espoused by cultural pluralists such as John Dewey involved largely European immigrant populations, comprised mainly of Anglo-Saxon and Slavic nationalities. Black, Native, and Latino Americans did not figure prominently within multiculturalism until the era of civil rights during the 1960s.

Multiculturalist scholars (Banks, 1986; Banks & Banks, 1993; Young, 1995) frequently refer to anti-assimilationism as ethnic revitalization, a sociological process which they suggest usually comprises three distinct, cyclical phases:

1 **Cultural Pluralism** *(1920-1950)*
- ■ a precondition phase characterized by ethnic polarization in which oppressed minorities seek a sense of group identity
- ■ problems are singularly attributed to colonialism, imperialism, or racism
- ■ school curricula promote and reflect ethnic identification
2 **Cultural Difference** *(1950-1980)*
- ■ a secondary phase distinguished by improved relations between minority and majority groups
- ■ problems are attributed to a variety of complex and interrelated social phenomena
- ■ school curricula incorporate minority cultures
3 **Institutional Reform & Neo-Assimilationism** *(1980-)*
- ■ a summative phase typified by social reforms which encourage other marginalized groups to demand further accommodation
- ■ conservative forces take advantage of this ethnic fragmentation to institutionalize restrictive policies
- ■ stage is set for a renewed cycle of ethnic revitalization.

Since the summative phase of ethnic revitalization in the United States and Canada corresponds chronologically with the postmodernist era, we should be able to identify some sociological commonalities. An obvious feature of phase 3, which substantively distinguishes it from the two preceding phases, is a concurrent movement toward liberal institutional reform on the one hand, and conservative neo-assimilation on the other. This Janus disposition has also been noted as an innate characteristic of postmodernism:

> There are really two postmodernisms: one radical and one conservative. Radical postmodernism thrives on the deconstruction of modernism and resists the status quo, while conservative postmodernism repudiates radical postmodernism. (Smith, 1992a, p. 81)

Russell Young (1995) has suggested six reasons for the rise of neo-assimilationist policies since 1980:

- First, institutional reforms such as desegregation and affirmative action produced a false of sense of ethnic harmony. At the onset of successive yearly declines in the American economy during the late 1970s, such losses were linked by conservative groups to the success of liberal social policies.

- Second, the widespread adoption by Anglo-Saxon Americans of *colour blindness*, which maintains that everybody is the same regardless of skin colour, was predicated on the assimilation of minorities into the mainstream culture.

- Third, charges of reverse discrimination were voiced by conservatives in response to the supposed excesses of reforms based upon cultural pluralism and cultural difference.

- Fourth, internal contradictions within minority groups remained unresolved. Activist feminists wrestled with conservative homemakers. Afro-American activists accused middle-class Blacks of being *oreos* - Black on the outside, but White on the inside. Militant homosexuals remained frustrated by their failure to convince suburban gays to adopt *Queer Nation* lifestyles.

- Fifth, advocates of cultural difference were confronted with the difficult task of reconciling conflicting cultural loyalties. Should middle-class White couples be allowed to adopt Black babies? Should second- or third-generation Asian-Americans be expected to relate to Asian or American cultural practices? How should children of mixed-racial heritage be raised?

- Sixth, the premise that increased levels of cultural sensitivity would translate into greater degrees of cultural harmony proved illusory. Proponents of cultural pluralism and cultural difference frequently failed to consider how deep-seated cultural pride could thwart programmes designed to end prejudice or discrimination.

Clearly, Young's explanations for neo-assimilationist trends since 1980 reflect key aspects of postmodernist theory:

- the recognition that modernist binaries such as Black/White and male/female cannot adequately model the complexity of contemporary Western society

- the revelation that sociologically static, homogeneous groupings such as women and Blacks are actually dynamic, heterogeneous social communities

- the realization that *progress* does not follow a linear path, and that it is neither inevitable nor predictable.

Although the final phase of ethnic revitalization has some postmodernist attributes, it is important to understand that multiculturalism as-a-whole is essentially modernist. This modernist foundation can be most clearly seen in the case of minorities who decline to participate in any form of multiculturalism. In such instances, the sense of alienation from the dominant Western culture is so strong that cultural separatism appears to be the only viable option.

To understand why some minorities opt for cultural separatism, we need to acknowledge that multiculturalism is fundamentally a Western construct based on the humanist ideal that individuals should be free to choose behaviours and values. For some minorities, this aspect of multiculturalism is unacceptable:

> Any society in which social structure and class are based on truths considered to be divinely revealed, therefore unquestionable, cannot accommodate "truths" which deny the basis of the claims to authority of its own structures. (Smith, 1994, p. 14)

Thus, the taken-for-granted need for critical discussion and personal opinion which lies at the very heart of multiculturalism creates intolerable levels of cultural dissonance for some minority students. Peter Smith (1994) cites the example of an Islamic graduate student who experienced discomfort with open-ended class discussions; in Islamic culture, education is marked by the ability to repeat received information, not critical intelligence.

The modernist universals embedded within multicultural education may also prove irreconcilable for students not seen as members of traditional minority groups, such as those from religious fundamentalist backgrounds:

> Even general classroom activities may pose problems for fundamentalist students. They are reluctant to disagree with authority figures, such as teachers, and their analytical skills, in general, are often poorly developed. Steeped in binary and simplistic values, they usually have little experience in dealing with issues of relativity or paradoxical situations. Further, they may be reticent to participate in physical or verbal activities, especially those whose parents believe that children "should be seen and not heard." (Clark, 1992, pp. 46-47)

■ Curricular Approaches

In Chapter 1 we discussed the quality of deliberate ambivalence that pervades postmodernist theory. Multiculturalism in the 1990s has acquired a similarly ambivalent cast; approaches currently being promoted may spring from assimilationist, culturally pluralist, or culturally different orientations. Many multicultural theorists maintain that politically effective approaches incorporate elements of all three perspectives: integrationist, pluralist, and particularist.

At the centre of many pluralist approaches to multiculturalism, however, is a shared assumption that mainstream Western culture is oppressive. Four generic responses taken by cultural pluralists to combat Western cultural domination have been identified and critiqued in multicultural publications (Collins & Sandell, 1992; Smith, 1994):

Attack Multiculturalism
- hidden negatives associated with Western society are brought to light through comparison with more benign cultures
- innately negative and likely to encourage counter-attack from other minority groups

Escape Multiculturalism
- boredom generated by the familiarity of Western society is countered through the study of exotic, romanticized cultures
- engenders dissatisfaction with Western society without suggesting any concrete course of action

Transformative Multiculturalism
- a common culture free of violence, oppression, and inequality is constructed from the best elements of diverse cultures
- fails to explain how moral-ethical criteria would be established and by whom

Repair Multiculturalism
- self-esteem of marginalized groups is improved through exposure to positive aspects of their cultural heritage
- assumes identification with ancestral pasts rather than with Western present.

Conversely, advocates of integrationist or particularist multiculturalism, such as Bob Milgram of the School of Visual Arts in New York City, tend to view the dominant culture more positively, as a glue holding the aggregate of American culture together:

> Whether the dominant culture glue is...toxic...is a matter of debate; some see the loss of this dominant agent as a death sentence for American society. I believe Milgram would claim that the metaphor should be a tossed salad rather than an aggregate. Bits and pieces flavor each other; the whole equals American culture. (Smith, 1994, p. 13)

1. We advocate a socio-anthropological basis for studying the aesthetic production and experience of cultures, which means focusing on knowledge of the makers of art, as well as the sociocultural context in which art is produced.

2. We acknowledge teaching as a cultural and social intervention and therefore, in any teaching endeavor, it is imperative that teachers not only confront, but also be consistently be aware of, their own cultural and social biases.

3. We support a student/community-centered educational process in which the teacher must access and utilize the students' sociocultural values and beliefs and those of the cultures of the community when planning art curricula.

4. We support anthropologically based methods for identifying these sociocultural groups and their accompanying values and practices which influence aesthetic production.

5. We advocate the identification and discriminating use of culturally responsive pedagogy that more democratically represents the sociocultural and ethnic diversity existing in the classroom, the community, and the nation.

6. We want to focus on the dynamic complexity of the factors that affect all human interaction: physical and mental ability, class, gender, age, politics, religion, and ethnicity. We seek a more democratic approach whereby the disenfranchised are also given a voice in the art education process, and the disenfranchised, as well as the franchised, are sensitized to the taken-for-granted assumptions implicit in the dominant ideology.

Figure 4: Multicultural Art Education Position Statements

(Wasson, Stuhr & Petrovich-Mwaniki, 1990)

The *tossed salad* metaphor might well be adopted by multiculturalists who maintain that contemporary American culture cannot be described as simply Western. Sahasrabudhe (1992) and Tomhave (1992) suggest that multicultural curricula should reflect five subcultures which collectively constitute the national culture of the United States: African, Asian, European, Hispanic, and Native.

The socio-anthropological diversity of contemporary American culture is a recurring theme in the six position statements developed by art educators Robyn Wasson, Patricia Stuhr & Lois Petrovich-Mwaniki (1992) reproduced in *Figure 4: Multicultural Art Education Position Statements*. In their *Statements*, Wasson et al. consider culture to be a transitional process whereby specific groups acquire a collective image, or world view, of themselves. All teachers must step beyond their own personal world views, and be open to the diversity of cultural experiences which exist among their student populations. This ongoing feature of professional development requires more than acquainting oneself with the literature on multiculturalism:

> It is no substitute for accessing the attitudes, values, and beliefs of persons from different ethnic or cultural groups. We believe that this is best done through anthropological approaches that involve talking to people, listening, observing, recording, interacting, checking responses, and constantly referring responses to the cultural context in which this interaction occurs. (Wasson et al., 1990, p. 237)

Wasson et al. recognize that school curricula often produce internal student conflict by valuing only one of the three sociocultural environments in which all students learn: popular/peer, minority/ethnic, and dominant/American. Such conflict can be reduced by ensuring that curricula value all three milieus at various points in the year.

Advocates stress that multiculturalism should not be considered by educators to be a discrete school subject but rather a pedagogic orientation to the cultural diversity of their students; international studies and global education, on the other hand, are more properly covered as elective courses (Sahasrabudhe, 1992, p.46). Global education (Pike & Selby, 1988; Stone, 1995a, 1995b) consists of four *dimensions*.

Spatial Dimension
- involves the interdependence of human beings and various socio-ecological systems
- art works are considered for their social, political, and economic qualities, as well as for their stylistic influences

Temporal Dimension
- stresses the connections that exist between time and space; includes futurist education
- art works are discussed for their present relevancy, as well as for their insights into past societies

Issues Dimension

- centres on aspects of contemporary lifestyles which do harm to people or the planet
- art works often facilitate classroom discussions of difficult issues, such as AIDS, overpopulation, and violence

Human Dimension

- maintains that spiritual or emotional commitment is needed to genuinely transform human behaviour
- art education offers many opportunities to achieve this goal within students.

Based upon a comprehensive model by Sleeter & Grant (1987), Patricia Stuhr (1994) has proposed five distinct approaches to multicultural art education: teaching the exceptional and culturally different, human relations, single group studies, multicultural education, and social reconstruction (see *Figure 5: Approaches to Multicultural Art Education*). Both the Sleeter & Grant and Stuhr models are predicated upon a very expansive, reconstructionist concept of multiculturalism which encourages learners to:

> become analytical and critical thinkers capable of examining their life circumstances and the social stratifications that keep them and their group from fully enjoying the social and financial rewards of this country. Or, if they are members of dominant groups, it helps them become critical thinkers who are capable of examining why their group exclusively enjoys the social and financial rewards of the nation. (Grant & Sleeter, 1989, p. 54)

Teaching the Exceptional and Culturally Different

Human Relations

Single Group Studies

Multicultural Education

Social Reconstruction

Figure 5: Approaches to Multicultural Art Education

(Stuhr, 1994)

■ **Teaching the Exceptional and Culturally Different**

Fundamentally assimilationist, this first approach assumes that minority groups need to be equipped with the knowledge, skills, and aesthetic values of the dominant American culture in order to compete for employment in the arts and participate in cultural activities. Curricula based on this approach attempt to remediate learning *deficits* thought to exist within minority learners rather than to eliminate cultural impediments within traditional models of art education. In most instances, minority students are *brought up to the norm* through minor changes in pedagogic style and curricular content, such as the addition of non-American exemplars. Reflecting its assimilationist intent, this approach favours discipline-based curricula which usually stress Western artistic traditions. Art forms and artists who represent discordant world views are seldom mentioned:

> Those who practice this approach may feel that once all
> teachers and students are indoctrinated into the one right way
> to teach and learn about art, they will have a stake in the
> Western fine art world; there will then be no need to practice
> radical social change. (Stuhr, 1994, p. 173)

■ **Human Relations**

This second strategy for implementing multicultural art education strives to foster self-esteem, promote group identity, reduce stereotypes, and eliminate systemic biases and prejudices. Conflict, controversy, and division are avoided; consequently, socio-cultural differences are given scant, superficial attention. The human relations model emphasizes curricula which highlight similarities among a broad spectrum of American society, emphasizing breadth rather than depth of understanding. Art education has a prominent role to play in this approach to multiculturalism, providing instructional activities devoted to a diverse array of holidays, festivals, and celebrations.

Art teachers need to closely examine such activities, however, to ensure that:

■ disciplinary integrity is not compromised through the assignment of superficial, busywork which does not provide any genuine opportunity for growth in art knowledge, skill, or appreciation

■ artifacts from other cultures being studied or reproduced, especially those with religious connotations, are presented in ethnographically correct contexts

■ decorative and celebratory forms of *school art* do not characterize the overall art curricula:

> Cranked-out rabbits and turkeys are *not* art education, listening
> to records as a time killer is not music education, and being
> a pilgrim does not a Thespian make. (Cormack, 1991, p. 42)

■ Single Group Studies

As the name implies, this approach involves the study of one particular cultural group in order to foster greater understanding, respect, and awareness. In this model, art educators present exemplars and biographical information drawn from a marginalized segment of the artworld. Attention is focused upon the artistic features which are unique to the selected group, and explanations are offered as to why the group exists outside of the mainstream artistic community. Although this approach does acknowledge and address aspects of cultural conflict, its rather timid focus on only one marginalized group tends to avoid any substantive challenges to the dominant culture. At best, this approach succeeds in broadening, but not reconstructing, the status quo, and raising awareness within the dominant culture of an alternative world view. Care must be taken not to promote escapism by excessively idealizing the group under study, nor selecting unduly exotic or unrepresentative marginalized groups:

> Escape multiculturalism is, therefore, hardly a serious approach to curricular multiculturalism. It belongs to the romantic thinking that created *Lost Horizon* or *Dances With Wolves*, beautiful in a sense, nostalgic, projecting a sense of loss, but in the end not suggesting a course of action beyond regret and sadness. (Smith, 1994, p. 16)

■ Multicultural Education

Sleeter & Grant (1988) speak of multicultural education as "cultural democracy" which "promotes cultural pluralism and social equity by reforming the school program" (p. 422). In practical terms, this is achieved by:
- hiring a culturally-diverse teaching/support staff
- avoiding stereotypical personnel assignments
- developing pedagogically-diverse instructional strategies
- presenting alternative world views throughout the curricula
- fostering co-operative, non-sexist learning environments.

Such reconstructed school settings set the stage for the implementation of art curricula which examine socio-cultural phenomena critically and reflectively. Frequently, such curricula are planned around substantive themes, such as the exercise of power and forms of knowledge, rather than discrete school subjects. Students are encouraged to challenge the curriculum, especially when it conflicts with their own lived experiences, and participation from members of the local community and beyond is actively sought. Tomhave (1992) has suggested that, in reality, comprehensive cultural literacy is not possible because the approach "falls short by not providing teachers with the "what, when, where, who, how, and how much" information they need in order to make multicultural curricular decisions" (p. 56).

■ **Social Reconstruction**

Whereas multicultural education strives to reform schools, this fifth approach to multiculturalism attempts to fundamentally reform society itself. Essentially postmodernist, reconstructive multiculturalist curricula focus squarely on structural inequalities within Western society. Students from marginalized groups are encouraged to deconstruct socio-cultural phenomena to discover how contemporary society works to their disadvantage; similarly, students from the dominant culture are asked to deconstruct such phenomena to find how society works to their advantage. Subsequently, all students are invited to construct new, most likely interdisciplinary, school curricula which respond to their individual and collective lived experiences.

Critics of social reconstructive multiculturalism have asked:
■ *Whose vision of a reconstructed Western society will be adopted?*
■ *How will dissident viewpoints be reconciled?*
■ *Can totalitarian methods for achieving the new social order be avoided?*
Proponents maintain that such concerns are unnecessary since everybody will be
 enabled and expected to practice democratic action for the
 benefit of disenfranchised sociocultural groups identified and
 investigated as a result of the enlightened curriculum. (Stuhr,
 1994, p. 177)
The assumed cultural universality embedded within this *enlightened* curriculum belies its postmodernist pretensions, effectively returning multiculturalism to its historically modernist roots.

Although Stuhr's progression of approaches to multiculturalism does gradually move away from modernist assimilationism toward postmodernist social reconstruction, multiculturalist reforms have come under increased scrutiny in recent years. In Canada, where multiculturalism has been official government policy since the 1970s, skeptics including Liberal MP John Nunciata have publicly railed against multicultural federal legislation as unnecessary and inherently patronizing to minority groups. Other critics have accused the Canadian government of adopting official multiculturalism as a covert way of maintaining the status quo by placating minorities with superficial shows of greater social acceptance.

Minority artists have been in the vanguard of such critical scrutiny; in particular, militant Black, gay/lesbian, and Native artists have increasingly lost interest in joining mainstream American culture, opting instead for cultural separatist movements such as Queer Nation and Nation of Islam. Curiously, the field of art education as-a-whole has failed to acknowledge such marginalized groups. Their voices are seldom acknowledged in art classrooms and, as we shall see, their appearances in the literature are usually limited to stereotypical cameos.

2.3 *Other* Voices

> We must world-travel with a loving rather than an arrogant eye.
> While the arrogant eye sees the other
> in terms of its own needs, desires, and interests alone,
> it is the loving eye that can encompass difference without erasing it.
>
> Laurie Hicks

The postmodernist concept of community of difference involves more than just respect for diversity; it also involves an extended understanding of *otherness*, a feminist construct first advanced by Simone de Beauvoir:

The "Other" defines each individual of every cultural group:
Otherness is a potential within each of us as we relate to
different cultures. (Garber, 1990, p. 22)

Developing a sensitivity to otherness begins with securing a sense of self, for only after locating our own cultural identity can we begin *world-travelling*, moving among and within communities different from our own.

In the above passage, Laurie Hicks (1994) describes world-travelling metaphorically as "a loving eye that can encompass difference without erasing it" (p. 155); she is cautioning educators to avoid the *pedagogy of erasure* which:

- avoids any critical examination of hierarchies, oppression, and abuses of power existing within cultural groups
- replaces the American self-identification of second- or third-generation minority students with ancestral group-identification
- strips cultural objects of their otherness by removing them from their functioning contexts and emphasizing similarities with familiar objects.

Teachers need to be especially wary of pedagogic erasure when dealing with significantly marginalized cultural groups. In this section, we will be attending to the voices of three very marginalized groups: Black, gay/lesbian, and Native. These three minorities have been selected, in spite of their infrequent appearance and shallow treatment in the literature, in part to provide specific illustrations of how pedagogic erasure in art curricula can hinder the development of a collective sensitivity to otherness in our profession.

■ **Black**

Cultural marginalization is especially difficult to overcome when oppressive practices find sanction in religious beliefs. Slavery, surely one of the most ignoble forms of oppression ever devised, has frequently been defended on theological grounds; in particular, the American slave trade was traditionally given Christian sanction based upon Chapter 9 of the Book of Genesis:

> Pre-Adamite theory, influential in the eighteenth century,
> allowed racists to account for separate origins of humankind
> and thus view some groups as inferior to others because of the
> circumstances of their creation." (Chalmers, 1992a, p. 139)

Ironically, biological determinism and cultural predestination both provide many contemporary Black athletes, entertainers, historians, politicians, and writers rationales for rejecting cultural pluralism (Ravitch, 1990, 1991; Smith, 1992b).

Black cultural separatism/monoculturalism is rarely mentioned in art education literature; however, within the broader education literature, demands that Black students be taught by Black teachers and calls for the creation of all-Black schools are commonplace. With some exceptions, American art educators have not relied on references to ancestral African heritages to bridge Black marginalization, opting instead to persuade Blacks to join mainstream culture:

> Too often, established galleries and museums treat minority art
> as primitive, naive, or archaeological and anthropological. It's
> important to showcase art by minorities as legitimate
> expressions of contemporary American life. (Chatman, 1993,
> p. 24)

This approach has been hampered by the fact that, unlike the performing arts, the American artistic community can point to relatively few Black role models. Reflecting on the early years of his distinguished career as a Black artist and educator, J. Eugene Grigsby, Jr. recalls meeting his first Black artist:

> I laughed because he didn't fit my stereotype of what an artist
> should look like. He was short and black and I knew he
> didn't have much education and that he was a stone mason.
> His hands were rough. And, all the artists I had ever seen
> were white, blond, and blue-eyed. (Young, 1995, p. 41)

Given the dominant White, middle-class culture of their profession, art educators have predictably sought non-reconstructive solutions to this legacy. A good example is the creation of an Office of Multicultural Development at the independent Milwaukee Institute of Art & Design (MIAD), set up "not to negate the contributions of western culture to the visual arts but to incorporate it with the philosophies of other cultures" (Chatman, 1993, p. 24). Paralleling Stuhr's multicultural education model, the Office has hired a culturally-diverse teaching staff, actively recruited minority applicants, revised Eurocentric curricula, and provided cultural sensitivity programmes for students and faculty.

Other art educators have tried to combat Black marginalization by instilling a sense of pride in their North American history. One such example was *Africville: A Spirit that Lives On*, a museum exhibition which opened at the Mount Saint Vincent Art Gallery in 1989. *Africville* documented 100 years of a Black community in Halifax which fell victim to urban planning/renewal in the late 1960s. A combination of attack and repair multiculturalism, the exhibition "captured the warmth of that lost community's life, and traced the shameful steps leading to its destruction" (Sparling, 1996, p. 40).

Social reconstructionists in art education, on the other hand, have stressed the importance of teaching Black (and White) students about the "continuum of ancient African cultures to the modern" (Grigsby, 1990, p. 67):

> In many parts of Africa, it is important to randomize the flow
> of paths, since evil spirits travel in straight lines. This belief
> explains why traditional Afro-American cabins were
> wallpapered with jumbled pages of newsprint and squares of
> magazine illustrations. (Congdon, 1989, p. 179)

Unfortunately, reconstructionists have frequently fell prey to pedagogic erasure by exoticizing elements of African art/aesthetics:

> The African image is an image by analogy...An object does
> not mean what it represents, but what it suggests. For
> example, the elephant is strength, horns are the moon, and the
> spider is prudence. (Congdon, 1989, p. 179)

In this instance, pedagogic erasure could have easily been avoided by drawing obvious parallels to the iconographic nature of Egyptian hieroglyphics and European stained-glass windows.

Postmodernist feminist art educators have drawn attention to the fact that Blacks have traditionally theorized through "narrative forms, stories, riddles, proverbs, language play, and in dynamic rather than fixed ideas" (Garber & Gaudelius, 1992, p. 20), as opposed to Western forms of abstract logic. Contemporary Black artist Faith Ringgold continued this traditional emphasis upon subjective experience in quilts like *Change: Faith Ringgold's Over 100 Pound Weight Loss* which documented her transition from a chronic over-consumptive to a woman fully in control of her life. In a performance work entitled *The Wake and Resurrection of the Bicentennial Negro*, Ringgold synthesized the African-American wake with African beliefs that "hold ancestral deities in a state of limbo until they are released through dance to return to the community in search of new lives" (Rouse, 1984, pp. 9-10). In *The Wake*, soft sculptures were used to represent drug addict Buba who dies from a heroin overdose and his abused wife Bena who dies from emotional trauma.

> Ringgold's narrative art is...in keeping with [bell] hooks'
> recognition that storytelling is a way to keep black history,
> genealogy, and community alive, a way to have vision for the
> future. (Garber & Gaudelius, 1992, p. 24)

▪ Gay/Lesbian

The cultural marginalization of gays/lesbians has proven especially difficult to bridge for two primary reasons (Honeychurch, 1995):

- First, their marginalization intersects two cultural sites which have historically demonstrated a low propensity for sensitivity to otherness - sexual identity and religious belief: "sexual orientation is, perhaps, the final human variable around which discrimination is openly encouraged and, in some instances, mandated" (p. 210).

- Second, unlike visible minorities marginalized due to gender and race, many homosexuals have practised self-erasure as "visual ventriloquists, ambiguously speaking and constituting meaning in ways which deflect attention away from sexually variant experience" (p. 215).

Although *the love that dares not speak its name* certainly appears to have had no trouble finding its voice on daytime talk shows, homosexuality has hardly managed a whisper in the field of art education. Fearing personal attack and/or loss of employment, gay/lesbian teachers have traditionally maintained a strict separation between their personal and professional lives. Nonetheless, gay/lesbian caucuses have been recently created in the American Federation of Teachers, the National Education Association, The College Art Association, and the Alliance for Museum Education (Lampela, 1995, 1996). It is critically important to understand that such organizations are:

> about much more than the sex of the person we take to bed [or] the political/public education aspect...I truly believe that I am good at what I do because of what I've learned by growing up a gay person...and I believe that there is something about my being gay that enhances my work of decoding, explaining, facilitating. (Richards, 1992, p. 6)

Research into the lived experiences of homosexual men and women has much to offer postmodernist scholarship for, of necessity, gays and lesbians have had to devise alternative notions of personal and cultural identity. It is worth noting that feminist theories, grounded as they mostly are in modernist gender polarities, do not adequately address issues of sexual orientation:

> Gender and sexuality, however, while allied, are not the same. As a consequence of the centering of gender distinctions, feminist ideologies may categorize lesbians and gay men fundamentally as male or female, making homosexuality incidental rather than central to identity and ideological, pedagogical, and political concerns. (Honeychurch, 1995, p. 211)

One must be especially careful not to confuse postmodernist feminist concepts of psychological bisexuality, such as Hélène Cixous' *l'écriture féminine* (page 44) with issues of homosexual identity and culture.

References to gays and lesbians in the literature are sparse, indeed; when present, they usually link homosexuality with such topics as AIDS, pornography, or moral degeneracy (Blandy & Congdon, 1990; Fehr, 1994; Stone, 1995a). Perhaps even more harmful, however, are articles which are overtly heterosexist. For example, in a 1990 paper *(devoted to helping writers achieve gender balance in art books, no less)* editor Robyn Turner suggests:

> where appropriate, the text should include positive accounts of motherhood and fatherhood, as well as those of female/male relationships. (p. 61)

Recently, a few excellent books have been published which should assist teachers in familiarizing themselves with contributions made by gay/lesbian artists, as well as provide insights into homosexual culture:

- *Forbidden Subjects: Self-portraits by Lesbian Artists* (Kelley, 1992)
- *Speaking for Vice: Homosexuality in the Art of Charles Demuth, Marsden Hartley, and the First American Avant-Garde* (Weinberg, 1993)
- *The Sexual Perspective: Homosexuality and Art in the Last 100 Years in the West* (Cooper, 1994)
- *Stolen Glances: Lesbians take Photographs* (Boffin & Fraser, 1991).

Scholarship in this area is roughly divided into one of two camps: essentialist and social reconstructionist (Honeychurch, 1995). Essentialists believe that since homosexuality has existed in virtually every culture, it is appropriate to speak of gay/lesbian artists of the past. Reconstructionists, on the other hand, believe it anachronistic and misleading to apply contemporary notions of gay and lesbian sexuality to earlier societies. Both groups, however, support the addition of *lost gay/lesbian* artists to traditional Western canons.

In many ways, current scholarship into sexual orientation parallels feminist and race advocacy of the 1960s. For example, raising the level of public sensitivity to the oppression and cultural marginalization of gay and lesbian students is a key objective for all of the newly-created educational caucuses. Educational activist Laurel Lampela (1996) has offered the following practical strategies for confronting homophobia in the classroom:

- Always interrupt oppression wherever and whenever it occurs in a way that is as thoughtful and effective as possible...Rather than ignore slurs, teachers can say those words hurt and will not be allowed.
- Understand that ending oppression is the responsibility of people in the non-oppressed group. If a colleague, friend, or acquaintance tells a homophobic joke, ask the person to please stop.
- Learn the history, culture, struggles, and triumphs of the oppressed person's group.
- Know the primary forms of discrimination perpetuated on the young person's group and put considerable attention on ways to combat it and overcome it both at the personal and institutional level. (p. 243)

▪ Native

Research into the cultural marginalization of aboriginal peoples around the world has been recently undertaken by several prominent art educators:

▪	Australia	*Adnayamathanha*	Rogers & Irwin (1995)
▪	Canada	*Inuit*	Vastokas (1996)
		Mi'kmaq, Maliseet	Stephen (1996)
		Wikwemikong, Sechelt	Rogers & Irwin (1995)
▪	New Zealand	*Maori*	Chalmers (1992a)
▪	South Africa	*Zulu*	Blaikie (1994a, 1994b)
▪	United States	*Navajo*	Stokrocki (1994)
		Sioux	LaBatte (1991)
		Tohono O'odham	Nelson & Lalemi (1991)
		Wisconsin	Neperud & Stuhr (1993).

Most of the studies cited have relied heavily upon qualitative, ethnographic methodologies and, in keeping with traditional Native story-telling, many have adopted descriptive, narrative formats (Blaikie, 1994a, 1994b; Stokrocki, 1994).

Several disparate factors have contributed to the tenacious cultural marginalization of Native peoples:

- ▪ The geographic remoteness of most reservations makes cross-cultural contact infrequent.

- ▪ A recent study in the United States identified 170 different Native groups (Wasson, Stuhr & Petrovich-Mwaniki, 1990).

- ▪ Native research is usually conducted by non-Natives who too often work from Eurocentric cultural perspectives (Rogers & Irwin, 1995; Stokrocki, 1994).

- ▪ Non-Natives wishing to develop a sensitivity to Native *otherness* have had their task made more difficult by the shortage of Native teachers and writers.

A recurring theme in the research is an aspect of marginalization unique to Native populations: reservations. Although all minority groups experience a degree of cultural dissonance during contact with Western society, reservation Natives are usually better able to maintain their traditions and resist assimilation than Natives living off-reservation. Reservation Natives who work or study off-reservation, however, experience the greatest degree of cultural discontinuity (Nelson & Lalemi, 1991). Thus, it is often inappropriate to speak globally of *the* Inuit, or *the* Navajo:

> Even among the Navajo...some [maintain] traditional [religious beliefs]; others are Mormon, Presbyterian, Catholic, and Baptist. Some sites are rural; others are urban...One therefore cannot characterize "the Navajo way" as one stereotypic set of ideas. Their culture is dynamic and changing very fast. (Stokrocki, 1994, p. 67)

Native research in art education has also been characterized by a deliberate attempt to avoid insidious forms of pedagogic erasure. For example, Tony Rogers and Rita Irwin (1995) have cautioned teachers not to automatically assume that their Native students identify with traditional beliefs or customs:

Teachers, by mentally locating students in a supposed cultural group or community, may actually dislocate them from their cultural base. Teachers must recognize that the traditional society is not today's society; therefore care should be taken not to erase the differences between those who choose traditional ways and those who choose to be innovative while helping their communities evolve into a new culture. (p. 19)

Warning against the tendency to romanticize Native cultures, Mary Stokrocki has called for "more documentation and dignity and less drama and romance" (1994, p. 68).

Pedagogic erasure has also been avoided by highlighting, but not exaggerating, the important differences which exist between Eurocentric and Native patterns of artistic expression. For instance, many Native peoples:

- conceptualize history as circular and repetitive
- consider art an integral part of personal identity and existence
- value continuity over innovation
- assign ideas to the custodial group rather than to individuals.

Art teachers striving to bridge Native marginalization frequently introduce artistic exemplars and artifacts into their curricula. Considerable sensitivity to Native otherness must be brought to bear in such circumstances; all Native artworks need to be carefully researched, selected, and presented in culturally-appropriate contexts, especially religious artifacts. Art teachers should to be able to distinguish between Native artworks which are traditional, transitional, and transformative (Neperud & Stuhr, 1993):

Traditional
- constructed using ancestral techniques and materials, such as natural fibres, animal skins, bones, shells, and glass beads
- used in traditional Native cultural activities
- conveys tribal resemblances, rather than individual likenesses

Transitional
- constructed using contemporary techniques and materials, such as yarn, cloth, and plastic beads
- used in powwows and contemporary ceremonies
- designs are bolder and brighter than traditional designs

Transformative
- constructed using modern techniques and media; involves Eurocentric art forms, such as prints, sculptures, and paintings
- frequently made for commercial enterprises
- reflects Eurocentric fine art aesthetic principles and values.

In Chapter 2 we acquainted ourselves with the current state of scholarship within art education in the areas of feminism and multiculturalism. Along the way, we encountered some additional postmodernist concepts, such as community of difference, sensitivity to otherness, and pedagogic erasure. The diverse nature of cultural marginalization became evident while we listened to three *other* voices: Blacks, gays/lesbians, and Natives.

In the final chapter of this book we will be discussing pedagogic responses from art educators to the challenges posed by postmodernist theory. Whether one supports the status quo, expanded canons, or ethnoaesthetics, art teachers everywhere need to carefully re-examine their current professional practices and ascertain how postmodernism can enrich their pedagogic portfolio.

Postmodernism has something to offer everybody - even established art educators like Mary Erickson. When criticized by Phoebe Dufrene (1994) for categorizing Egyptian art as *European* and Native American art as *non-Western*, Erickson replied:

> If I have contributed to "the same old racial/cultural stereotypes," I am sincerely sorry. Meanwhile, let me urge you to take heart. Though you may not be convinced...I, for one, am listening. I hear you, and I'm learning. (p. 254)

3 Doors and Mirrors

> *Art opens doors; equally, it establishes the door-frame.*
> *Art mirrors but only what is selected in the mirror.*
>
> Paul Duncum

Although throughout this century art educators have responded to trends within the wider field of education, they have not paid similar attention to changes within the discipline of art. As a result, art activities currently taught in schools often bear little resemblance to those of the contemporary art world. Ironically, many students today receive a more valid form of art education outside of school, due in part to the commodification of art by the mass media:

> In the popular mind and popular culture, the postmodern is
> evidenced in the eclecticism of Michael Graves' architectural
> designs; Philip Glass' desequentializing music, as well as rap
> and hip-hop; Alice Walker's denarrativizing literature; Louis
> Lawler's and Carrie Mae Weem's defamiliarizing photography
> ...To take the obvious narrative out of literature; to create
> music that repeats themes and minor variations, but does not
> develop these as composers did in the past; to use photography
> not to mirror reality, but to show us the underbelly of cultural
> institutions and beliefs; such are the strategies of popular
> postmodern art. (Haynes, 1995, pp. 45-46)

The increasing irrelevance of school art has caught many art educators off-guard. Preoccupied with efforts to stave off assaults from technophiles and educrats fixated on issues of curricular accountability and budgetary efficiency, art teachers have been simply too busy to notice the arrival of postmodernist art. The long reign of modernism lulled teachers into a state of artistic complacency; for decades they could keep abreast of developments in the art world simply by familiarizing themselves with the latest -ism popular with the avant-garde elite:

> The job description of the art teacher, like that of Mary's
> lamb, was to make the children laugh and play...The modern
> artist ignored society and consequently had little impact on it.
> The modern art educator ignored the art world and produced
> a visually illiterate generation. (Fehr, 1994, p. 214)

As educators gradually become more aware of the place postmodernist art holds in popular culture, the need for attendant curricular reforms becomes more urgent. If we truly believe that art opens doors, it is important that the door frame be located at the threshold of equal opportunity. If we truly believe that art mirrors reality, it is important that the reality we construct be as diverse as the society in which we live. Postmodernist art has much to offer those wishing to find doors and mirrors in art education.

In this chapter, we will examine a number of responses to this challenge which have been proposed by prominent art educators. In some instances, attempts have been made to incorporate postmodernism within existing models of art education; in others, efforts have been undertaken to reconceptualize the ways in which art can, and should, contribute to the education of citizens living in a democratic society. Regardless of the approach taken, all of the curricular responses have had to pierce two cloaks of mythology which envelope *status quo* art education:

Myths Related to Creative Self-Expression

- children should be left alone when creating
- art instruction should focus on creativity
- artistic processes are more important than artistic products
- children perceive the world more clearly than adults
- child art cannot, and therefore should not, be evaluated
- teacher talk interferes with creative self-expression
- art should involve a wide range of materials and activities

Myths Related to Modernist Art

- art has inherent value
- art is a universal language
- art can be studied outside of production and appreciation
- fine art can be distinguished from other forms of art
- art interpretation is the domain of art experts
- all art can be understood using Western aesthetic models
- art instruction should always begin with objects.

Figure 6: Mythologies in Art Education

(Eisner, 1973-74; Freedman, 1994a)

One of the most interesting aspects of mythology is the frequency with which myths have subsequently been proven to be true, or at least substantively rooted in events which really happened. Even more astounding, however, is the number of instances in which researchers have made such discoveries by merely keeping an open mind and approaching the myths as if they were literally true.

A good case-in-point involves the famous statues of Easter Island. When archaeologists in the late 19th century asked the dwindling native population how their ancestors had moved the statues from inland quarries to the shoreline, they were told over and over again that *"the statues walked."* Naturally, this too-simple explanation offered by the natives was immediately discarded as colourful folklore fabricated by a primitive people who could no longer recall how such feats had been achieved. For decades, scores of Western archaeologists advanced sophisticated theories, all to no avail. Finally, one team decided to re-think the natives' claim that the statues had *walked*. In on-site re-enactments using ropes and replicas made from moulds, they demonstrated conclusively that the statues could, indeed, have walked. First, the replica statues were raised vertically using the ropes. Then, the heavy megaliths were moved horizontally by alternatingly tipping the statue to one side and swinging the other side forward. Any person living alone has used this simple strategy to move the refrigerator and retrieve objects which have fallen behind it, or to move the chesterfield and vacuum dust bunnies which lurk underneath it. So, it appears that the statues of Easter Island really did walk, after all; but it took an open mind to unlock the truth behind the myth.

Thus, the myths presented in *Figure 6: Mythologies in Art Education* need to be approached with an equally open mind; like the statues of Easter Island, it is quite likely that many of the alleged myths will ultimately be proven to be true. Nonetheless, for art educators struggling to address the challenges posed by postmodernist art, the mythologies related to creative self-expression and modernist art in *Figure 6* collectively form an agenda for curricular change. Before we begin to discuss any of the specific curricular responses presented in the literature, however, a few contextual realities need to be acknowledged:

- The proposed responses to postmodernist art need to be visualized as part of a continuum which ranges from minor revisions to existing models at one end, to substantively reconstructed notions of art education at the other.
- It should be understood that art educators rarely espouse curricula grounded within a singular perspective; in most instances, they support curricula which are constructed from an eclectic assortment of instrumentalist, essentialist, and postmodernist concepts.
- No matter how much we may hate to admit it, we are all a product of our time; generally speaking, older art educators favour reforming existing models of art education to incorporate postmodernist art, and younger art educators tend to support more reconstructive responses.

3.1 Resilient Art

Is what we are experiencing just one more quarrel
of the ancients and the moderns or, to dress things up a bit,
between moderns and postmoderns?
I think it likely that after a period of intense controversy and debate
there will be some revision of the content of general education
but that the traditional classical line, as it were, will hold.

Ralph Smith

The resilient nature of contemporary education has been extensively documented in the literature. Despite the cyclical reforms noted by Arthur Efland in *Figure 1: Historical Patterns in General Education* (page 14), elementary and secondary education have remained substantively unchanged since the First World War. Such curricular stagnation is not new; education in the Western world has historically exhibited resistance to change:

> To say that schools were for centuries stagnant and unable to become relevant to their times is to state the obvious. A like statement could be made of our own times in the United States. Today we are experiencing a similar kind of cultural inertia even through we have spent vast amounts of energy and resources to achieve change. (Longstreet & Shane, 1993, p. 7)

It is clear, however, that change during the 20th century has accelerated exponentially and continues to do so. Writing in 1981, futurist Harold Shane suggested that "we may be on the threshold of major changes in industrial society that...can rearrange the world we have known with spectacular suddenness" (p. 73). A mere 15 years later, Shane's forecast appears to have been right on-the-mark; the postmodernist age has indeed rearranged our world with spectacular suddenness. The educational system, unfortunately, has remained essentially the same. Our challenge, therefore, is to avoid educational anarchy, while simultaneously bringing schools as quickly as possible into the postmodernist era.

To meet this challenge, Shane has proposed that educators adopt an *evolutionary curriculum change paradigm*, premised on Thomas Kuhn's (1970) model of scientific revolutions:

> The paradigm for scientific change starts from an existing tradition, then a set of anomalies related to the functioning of the tradition arises leading to a crisis and proposal of a new paradigm to replace the traditional one. A battle of conflicting ideas ensues with the new paradigm becoming accepted and identified with tradition. (Longstreet & Shane, 1993, p. 66)

Shane's approach is characteristically postmodernist in that it acknowledges the importance of our cultural heritage as a point-of-departure, as well as the need to attend to "social indicators of change":

> Designing learning experiences that contribute to productive transitions between our contemporary realities and our likely futures would lead to an evolutionary curriculum for the future. (p. 67)

Although reconstructionist perspectives are frequently equated to futurist concepts, this connection should not be automatically assumed. Futurists rarely exhibit the missionary zeal and political agenda that drive reconstructionist advocates. So, for our purposes, Shane's evolutionary curriculum change paradigm offers a practical conceptual framework for the implementation of either reformist or reconstructionist responses to the impact of postmodernist theory within art education.

As we begin to examine responses which suggest that postmodernist theory can be successfully incorporated within existing models of art education, it is important to appreciate two fundamental nuances:

- *resilient* is not a synonym for *resistant*
- *reform* is not an antonym for *reconstruction*.

The responses to postmodernist theory appearing in the next few pages do not propose that the status quo in contemporary art education be maintained; quite the contrary, all acknowledge an urgent need to address the fundamental issues raised by postmodernist scholarship. Unlike curricular reconstructionists, however, they propose to accomplish this task by:

- retaining at the core of art curricula the cultural heritage of Western civilization:

 > During such a period of cultural conflict and fragmentation, I think it is important that we reaffirm our belief in art as a special and precious kind of human accomplishment that is expressive of indispensable human values. This means among other things the preservation of art's aesthetic character and an appreciation of its major achievements. (Smith, 1992a, p. 74)

- enriching that heritage with non-Western, non-modernist, pluralist perspectives.

■ **The Case Against Reconstructionism**

In response to reconstructionist articles published in a thematic issue of *Studies in Art Education*, Elliot Eisner (1994) posed the following questions which collectively present the case for reformist opposition to reconstructionism in art education:

■ *Where is the delight, the creative thinking, and aesthetic experience in reconstructionist models of art education?*
Considering the central importance of creativity and self-expression in art curricula throughout this century, one should not be surprised to find this question high on any reformer's list of criticisms. For some art educators, reconstructionist concerns about gender, racial, and ethnic marginalization seem especially inappropriate as curricular themes for young children. In reply, reconstructionists argue that since cultural attitudes are acquired by students in their formative years it is critically important that issues of marginalization be addressed in primary grades. For many reformers, even more serious problems arise from the lack of attention paid by reconstructionists to studio and intuitive aesthetic response activities. Critics suggest that the cognitive and linguistic emphases within reconstructionist curricula threaten to transform art education into little more than an academic debating club.

■ *Since the major mission of such approaches to art education is the reconstruction of society, why should art teachers undertake this task?*
The need for all teachers to attend to the emotional and spiritual needs of their students is not being questioned here; rather, critics are asking whether or not social reconstruction ought to be the primary mission of art educators: *Aren't other educational specialists better equipped to facilitate social reconstruction? What aspects of the professional preparation of art teachers lead reconstructionists to believe that art educators are capable of reconstructing society? Wouldn't social reconstruction be more adequately addressed within other curricular areas such as social studies?*

■ *Can't works of art be meaningfully experienced without placing them in economic, political, or historical contexts?*
Although reformers readily acknowledge the limitations inherent in formalist response techniques such as visual scanning, they do not believe that works of art always need to be deconstructed to be meaningfully experienced. Critics point out that many artifacts considered to be great works of art have been produced by artists and/or cultures about which we still know very little; nonetheless, despite our lack of insight into the economic, political, or historical contexts surrounding their creation these works have inspired countless individuals and contributed significantly to our cultural heritage.

- *If pluralism is a virtue, then why shouldn't reconstructionists be more accepting of other models of art education?*

 The messianic, bordering on totalitarian, fervour with which many social reconstructionists promote their ideas lends credence to the charge that reconstructionists are intolerant of other viewpoints. Critics frequently point to the paradoxical inability of cultural pluralists to accommodate non-pluralist cultures. As well, reconstructionist scholarship is often criticized for its internal inconsistency and tendency towards Orwellian, *Animal Farm* double-speak. For example, in our own field of art education reconstructionists routinely censure modernists for their assumptions of universality, preference for form over meaning, prediction of a better tomorrow, and bias in favour of elitist and patriarchal structures - while at the same time promoting a vision of society which assumes universality, prefers meaning over form, predicts a better world, and favours democratic and matriarchal structures.

- *Won't the emphases upon social and cultural issues in reconstructionist models make art a handmaiden to social studies?*

 Despite the fact that throughout most of this century art educators have promoted the instrumentalist value of art activities, especially in relation to the development of positive psychological factors such as self-esteem, creativity, self-expression, and social interaction, many reformers remain curricular essentialists at heart. It should come as no surprise, therefore, to learn that reformers criticize reconstructionists for appearing to be more concerned with issues of cultural marginalization than opportunities for artistic development. As far as many curricular reformers are concerned, any inordinate preoccupation with social reconstruction has the potential to overshadow the inherent value of art as a school subject and relegate art to a subservient role as handmaiden to social studies.

- *Why shouldn't Western values, supplemented by the values of other cultures, remain the dominant theme in American schools?*

 It is important to reiterate that curricular reformers do acknowledge the need for greater levels of pluralism within art education; notwithstanding such acceptance, however, they maintain that Western society does not warrant the blanket condemnations so frequently found in reconstructionist literature. Perhaps the best defence for Western society lies in its ability to accommodate alternative political viewpoints such as social reconstructionism:

 > [Diane] Ravitch agrees with those who speak of the need for a round table where persons sit as equals and at which racism, sexism, elitism, and ethnocentrism have no place. But she asks us to realize that the table itself, which is the enabling instrument of open and free discussion, is the Western political tradition. (Smith, 1992a, p. 83)

- *Is it realistic to expect schools and communities to accommodate the degree of pluralism that reconstructionists recommend?*

Painting worst-case scenarios is a time-honoured political strategy, and Eisner plays this card to effect when reminding reconstructionists that the city of Los Angeles is home to over 100 different linguistic groups. Clearly, art educators cannot be expected to familiarize themselves with literally dozens of hiddenstream cultures. In response, reconstructionists appeal to the common sense of teachers working within culturally-diverse settings:

> We simply can't teach everything, and we certainly can't teach it in depth. But such issues are not a reason to ignore diverse artistic and cultural traditions. Rather, they are an opportunity to re-assess what we believe art is, what it means and stands for, which art is good, and what art is good for, for children and for adults, and to make our selections on the basis of these decisions. (Delacruz, 1995, p. 59)

- *What does one do when value differences among culturally diverse groups become irreconcilable?*

This is a somewhat specious criticism since classroom teachers are required to mediate and reconcile disputes among students on a daily basis. Strategies developed for conflict resolution may be as readily applied to multicultural situations as any other. Reconstructionists stress the need to address cultural differences in non-confrontational, non-accusatory contexts - one rarely changes personal value systems on the basis of fear, power, or guilt. At the same time, however, reconstructionists reject the homogenization or avoidance of cultural differences as a way of reconciling classroom tensions; instead, they recommend the adoption of pedagogies which inculcate among students an appreciation for the postmodernist *community of difference* concept.

- *Can outsiders to a culture really secure the emic perspective - an insider's view?*

The answer to this somewhat rhetorical question is clearly *no*; however, it does underscore an important issue raised by reconstructionists and cultural separatists. An extension of criticisms levelled against systemic racist and sexist structures within modernism, claims by some reconstructionists that members of the dominant culture cannot adequately address the needs of marginalized groups are frequently thrown back at reconstructionists. *Can men treat women fairly? Do Black children need to be taught by Black teachers? How can straight society truly understand the discrimination experienced by gay men?* Again, reconstructionists counter with appeals to reason and common sense; obviously, none of us can fully appreciate life experiences beyond our own, but we can attempt to bridge that gap by taking deliberate measures to acquaint ourselves with the diverse cultures which surround us.

▪ Reforming Traditional Models of Art Education

Advocates of reformist approaches to postmodernist theory constitute a most diverse group, indeed; they include such prominent art educators as Fiona Blaikie, F. Graeme Chalmers, Elliot Eisner, Dennis Fehr, Lynn Hart, David Henley, Juliet Moore, Annie Smith, Ralph Smith, and David Templeton. In the literature this group has addressed a number of critical issues related to postmodernist theory, and has offered a variety of strategies for increasing levels of cultural pluralism within traditional models of art education:

> I believe that any overtly political position presented as the dominant and correct view by the teacher in authority is problematic, particularly in terms of typical school populations, which are diverse in sensibility and beliefs. In this regard, Collins and Sandell's (1984) model for a pluralist approach is a more equitable alternative than the integrationist model, both morally and educationally. (Blaikie, 1992a, p. 52)

Reformers believe that traditional models of art education are resilient enough to retain traditional Western art forms and practices while embracing culturally pluralistic exemplars and concepts. For many art teachers, this approach to reform translates into relatively direct changes to existing curricula:

- experimentation with alternative studio media and technologies
- exploration of non-Western concepts of space and design
- expansion of established artistic canons
- exposure to hiddenstream art and artists.

For others, however, the challenges posed by postmodernist scholarship demand more substantive, though admittedly not reconstructive, approaches to curricular change. More specifically, reformers have critically examined the conceptual foundations of instrumentalist and essentialist models of art education and have suggested ways in which both philosophical strands can adapt to the postmodernist age.

▪ Revisiting Lowenfeldian Curricula

Since the end of the Second World War the curricular principles outlined by Viktor Lowenfeld (1947) in his text *Creative and Mental Growth* have become virtually synonymous with instrumentalism in art education, especially at the elementary school level. At the heart of Lowenfeld's model lies a triangular interrelationship between child art, Piagetian developmentalism, and psychology. So great has been the impact of Lowenfeld's conceptual framework in the field-at-large that the resultant pedagogic principles have acquired mythological status. Seven of these pedagogic principles can be found within *Figure 6: Mythologies in Art Education* under the heading of "Myths Related to Creative Self-Expression" (page 66).

In the past few years, art educators (Freedman, 1994b; Henley, 1991) have begun to openly challenge critical aspects of Lowenfeld's developmentalist theories of child art. In particular, doubts have been expressed about the assumed universality of child art. It has been suggested that similarities among examples of child art from around the globe, such as those extensively documented in Rhoda Kellogg's classic text *Analyzing Children's Art* (1969), have resulted from the internationalization of images derived from popular Western culture rather than from parallel modes of artistic development.

Working within a different vein entirely, curricular reformers such as David Templeton (1990) and Lynn Hart (1991a) have called for a rejection of Lowenfeld's hands-off approach to teaching art, and a reduced emphasis upon modernist tenets such as originality, inventiveness, and spontaneous self-expression. Instead, they suggest that teachers dramatically increase the proportion of direct instruction in their art curricula:

> Expressions of frustration about their art is not a matter of young artists struggling to get out of society's straitjacket of conformity. More often than not, we are confronted by a young, astute intellect which knows lack of information when it is absent. All humans want to be competent. Praising children for art they deem incompetent is not encouraging to them. It is baffling. (Templeton, 1990, p. 34)

Such calls for direct instruction are not aimed solely at the development of production skills; they also involve the exposure of children to art history, art criticism, and aesthetics, wherein the use of non-Western exemplars, past and present, is routinely recommended.

Given that postmodernist theory questions the concept of absolute originality, as well as the mythical "autonomous, male fine artist who work[s] alone in a studio, freely self-expressing and intuitively creating" (Freedman, 1994b, p. 160), it should come as no surprise that *copying*, another practice expressly forbidden in Lowenfeldian art education, has been reconsidered by curricular reformers. Despite the legacy of classical and medieval craft guilds, the modernist fixation with original work has dominated Western art throughout this century; in art education the emphasis upon originality has been even more pronounced, partially as a lingering aversion to the tedious *copy books* widely used in elementary schools until the First World War (Clark, 1994). Anna Kindler (1992) has suggested that, unlike adults, children use copying to facilitate their movement away from memory-based art to visually-based art. Art historian Annie Smith (1992) has maintained that "copy wrong" only occurs "when no new learning takes place, or worse yet, when wrong information is passed on, or when the same thing is learned over and over" (p. 42). Finally, Irvin King (1991) has offered new perspectives on another Lowenfeldian taboo: *colouring books*. According to King, colouring books facilitate eye-and-hand coordination, provide emotional relief, and reduce studio performance anxiety.

The instrumentalist emphasis upon creative self-expression has also been revisited. In several recent publications I have urged the development of art curricula based upon *self-* and *cultural-disclosure* (1987, 1991, 1992a, 1994). Disclosure-based curricula attempt to bridge the gulf between instrumentalist *education through art* and essentialist *education in art*. So, I sought a linguistic construct other than *expression* to denote a more deliberate approach to artistic activity, an approach that reflected process as well as product and recognized the need for expressive precision within studio production. I selected *disclosure* to achieve this subtle but crucial nuance and to convey forms of student artistic activity that contain differentiated levels of product/process, ability/attitude. While my tripartite model for elementary and secondary art curricula admittedly retained modernist characteristics, it did address several postmodernist issues:

- the primacy of content over form
- the critical role of self in society
- the rising importance of popular art.

From child art to colouring books, self-expression to self-disclosure, it is obvious that the postmodernist pairing of art with society has provided the philosophical impetus for many re-assessments of Lowenfeldian instrumentalism:

A repudiation of Lowenfeld's theory of creative growth could
not be clearer. It is no longer as important to express one's
inner self as it is to function as an informed and intellectual
member of society. (Moore, 1991, p. 38)

- **Discipline-Based Art Education: Curricular Chameleon**

Educators wishing to reform traditional art curricula to meet the challenges posed by postmodernist scholarship have also turned their attention to essentialist models of art education. Discussed previously within Chapter 1, essentialism refers to a broadly-conceptualized educational philosophy which emphasizes our cultural heritage and the need to transmit time-tested knowledge from one generation to the next. Essentialists within our own field maintain that art has inherent value as a discrete school subject and, furthermore, that art ought to be part of every elementary or secondary school core syllabus. Typically, essentialist curricula reflect the following generic tenets (Holt, 1990):

- learning demands discipline and perseverance
- issues of accountability apply to teachers and (especially) students
- teachers need to present themselves as authority figures
- the assimilation of prescribed subject matter is of primary importance.

Historically speaking, essentialist arguments for art education have not garnered much acceptance, especially within elementary grades where art retains a foothold on instrumentalist grounds. It is true that the inherent value of art as a discrete subject has found greater recognition in secondary grades, but only in the context of art as a curricular option.

Since the mid-1980s essentialism in art has reached unprecedented levels of support due to the vigorous promotion of discipline-based art education (DBAE) by the Getty Center for Education in the Arts. When first introduced DBAE's curricular emphases upon studio, art history, art criticism, and aesthetics generated deep and diverse criticism (Hamblen, 1993):

- advocates of child-centred pedagogy panned DBAE for its inattention to individuality and holistic learning (Burton, Ledermen & London, 1988)
- art specialists disliked the degree to which DBAE transformed art into an academic clone complete with sequenced instruction, predictable outcomes, and testable learning (Hamblen, 1988)
- cultural pluralists were unhappy with DBAE's heavy reliance upon Western fine art, visual exemplars, and formalism (Blandy & Congdon, 1987).

A decade later, however, art educators have become less confident in their assessments of DBAE; in particular, profound disagreements have arisen over DBAE's compatibility with postmodernism. On one side are those who equate DBAE with the worst excesses of high modernism:

> Politically, critics of D.B.A.E. are similar to post-modern critics of high-modernism in that they are both liberal reactions against what is perceived to be conservative and officially sanctioned movements...[critics] have labeled the approach by Getty: conservative, formalistic, essentialistic, dogmatic, undemocratic, paternalistic, non-creative, sexist, racist, reductionist, and philosophically misguided. (Holt, 1990, p. 44)

Whew! On the other side of this great divide are scholars who maintain that DBAE is entirely compatible with the central postmodernist goal of cultural pluralism because of its ability to:

- recognize, acknowledge and celebrate racial and cultural diversity in art within our society, while affirming and enhancing self esteem and pride in one's own heritage
- promote cross-cultural understanding by identifying similarities (particularly in the role and function of art) within and amongst cultural groups
- address, in all art disciplines, and not just art history, issues of ethnocentrism, bias, stereotyping, prejudice, discrimination, and racism. (Chalmers, 1992b, p. 16)

Several explanations for these polarized viewpoints have been put forward in recent years; invariably they point to the increased acceptance of non-Western art forms and practices since DBAE's initial conceptualization (Fehr, 1994; Hamblen, 1993; Moore, 1991; Wolcott, 1996).

Karen Hamblen (1993) has even gone so far as to suggest that positions currently advocated by Getty are sufficiently distinct from earlier versions to warrant a new moniker, such as *Neo-DBAE*:

Although some types of art, such as feminist, folk, domestic, commercial, craft, etc., are not included in DBAE curricula to the extent some might wish, their presence represents a major deviation from the fine art "look" of the 1980s and are strong indications that Neo-DBAE has postmodern leanings. (p. 10)

Similarly, Fehr (1994) has noted the increasingly pluralistic canon promoted by Getty and renamed DBAE *multicultural discipline-based art education* (MDAE).

As is frequently the case in real life, arguments can be made for both positions: "[DBAE's] intellectual ideas are post- and pre-modernist, while its aesthetic theories and practices are essentially modernist" (Wilson, 1988, p. 64). Correspondingly, middle-of-the-road curricular reformers such as Anne Wolcott believe that modernist and postmodernist pedagogies are capable of being melded into new instructional approaches. Working from the premise that art curricula in elementary and secondary schools remain predominantly modernist, she suggests that teachers use formalist instruction as a foundation for more interpretative studies. Wolcott asks teachers to consider adopting strategies developed by Arthur Danto in *The Transfiguration of the Commonplace* (1981):

He insists that we cannot overlook the fact that works of art derive their identities and structure from historical and causal matrices. Their meanings and associations are bound to the cultural framework of the time and assume causal connections with an artistic environment. Thus works of art embody ideas that express an age - the beliefs and attitudes that define a world by those living in that period. It is through the attributes of style and expression that the viewer discovers these ideas. (Wolcott, 1996, p. 74)

Causal connections that exist among artifacts, artists, and groups can provide fertile ground for class discussion (McFee, 1986):

- *What are the norms for artistic behaviour; who does what, when and how?*
- *What is the relationship of the artist to the rest of the group?*
- *What are the ways that artists express the general intentions of the group?*
- *How does a given artist's self-concept compare with the norms for other people in the group? What values are clearly accepted or rejected in and through the art of the group? What are the group's beliefs and art's antecedents and consequences? What is art based on?*
- *What effects is it expected to have? How much variation in artistic behaviour is tolerated? How should the artist be rewarded?* (p. 11)

3.2 Reconstructive Art

*A socially reconstructed art education could enrich
student understanding through the inclusion of teaching about
the immense power of visual culture,
the social responsibility that comes with that power, and
the need for the integration of creative production, interpretation,
and critique in contemporary life.*

Kerry Freedman

Curricular reconstructionists believe that existing models of art education are incapable of adequately responding to the challenges posed by postmodernist scholarship. During the last decade several provocative curricular alternatives have been suggested by such prominent scholars as Kerry Freedman, Deborah Haynes, Laurie Hicks, Harold Pearse, Lois Petrovich-Mwaniki, Patricia Stuhr, Robyn Wasson, and Janet Wolff.

To understand why reconstructionists reject the viability of reforming traditional approaches to art education, we need to step back for a moment and place cultural pluralism in art education within a comprehensive framework. The immense diversity that exists among pluralists makes this no simple task, but organizing the various approaches according to the disciplines from which they derive their inner logic offers a practical way to proceed. Using this strategy we can place individual approaches to cultural pluralism within one of three disciplinary strands (Duncum, 1991):

- anthropology/sociology
- ethnography
- social criticism.

The disciplines of anthropology and sociology differ primarily in the former's focus on non-Western societies and the latter's interest in Western society; both share a belief that artifacts need to be considered within socially-derived contexts. These two parallel research paths can be associated with work by early cultural pluralists such as Edmund Burke Feldman whose approach was largely anthropological and Laura Chapman whose work was mainly sociological:

While Feldman focuses upon allegedly, universal themes [such as death, love, and joy], Chapman establishes as tools of analysis paired opposites like temporary and permanent, unique and multiple, innovatory and traditional. The effect is the same: to demonstrate links between ordinarily disparate artifacts and to see the taken-for-granted in a new, broader perspective. (Duncum, 1991, p. 46)

The second disciplinary strand, ethnography, involves the observation, description, and evaluation of activities undertaken by members of a specific social group. As one might expect, ethnographic research relies heavily upon the *lived experiences* of individuals, especially as they relate to cultural phenomena. Cultural pluralists within art education most closely linked to this approach include F. Graeme Chalmers and Karen Hamblen. Ethnography also plays a role in socially critical research, but primarily as a starting point for more radical curricular change.

The social criticism approach rejects the anthropological/sociological and ethnographic strands for their failure to acknowledge the undercurrent of social conflict which flows within and among individuals and groups:

A socially critical approach stands in marked contrast with both the preceding approaches. The anthropological view of culture as a whole way of life is rejected in favour of culture as a whole way of conflict. Rather than viewing human societies are giant human bodies with all parts working to support the whole, societies are seen to be comprised of groups with competing interests that are always in tension. (Duncum, 1991, p. 51)

Thus, socially critical research differs from ethnography in its interest in social structures as well as individual lived experiences.

Throughout this chapter we have described the diversity of responses to postmodernist scholarship in terms of reform *versus* reconstruction. Using Paul Duncum's disciplinary framework, we can easily align reform with anthropology/sociology/ethnography and reconstruction with social criticism. Now we can explain why reconstructionists believe that traditional models of art education are incapable of adequately responding to postmodernist scholarship. Curricular reconstructionists see within anthropology/sociology/ethnography deeply-embedded cultural elements which contrast sharply with the basic characteristics of social criticism. Viewed collectively, these elements produce incompatible polarities:

- cultural functionalism *versus* cultural conflict
- social individualism *versus* social collectivism
- cautious reform *versus* radical reconstruction.

It is these inherent incompatibilities which have driven reconstructionists to reject notions of curricular reform and to conceptualize new models of art education.

■ The Nature of Reconstructionist Pedagogy

Critics of social reconstruction in art frequently maintain that the heavy emphasis placed upon political activism in reconstructionist curricula effectively eradicates art education as we have known it for the past one hundred years. Such censure, however, rarely deters true believers from their avowed intent to employ art in the service of social justice and pluralistic democracy; in fact, reconstructionists such as Harold Pearse (1992) herald the demise of traditional art education as a necessary precondition for reconstruction: "The first step is to see art as a social process and to rename it *cultural production*" (p. 250).

■ *What might the social process behind cultural production involve?*

To answer this question, we can cite two reconstructionist principles put forward by the Calouste Gulbenkian Foundation (1982) as part of the British inquiry into *The Arts in Schools*. The Foundation suggested that culturally pluralist education:

■ emphasizes cultural relativity by helping [pupils] to recognize and compare their own cultural assumptions and values with [those of diverse cultural groups]

■ encourages a cultural perspective by relating contemporary values to the historical forces which moulded them. (para. 55)

Thus, reconstructionist curricula are designed to develop a sense of cultural relativity and cultural perspective among all students, whether they be members of the dominant culture or some marginalized group. Pedagogically speaking, this is accomplished by designing curricular activities which prompt students to compare their personal cultural values with contemporary and historical alternatives. The ultimate goal is to inculcate the postmodernist *community of difference* concept as the basis for a more culturally pluralistic and democratic society.

■ *What role do artifacts play within reconstructionist curricula?*

Within reconstructionist art curricula artifacts are valued primarily for the meanings that they convey, rather than for the formalist characteristics that they exhibit, and their ability to spark connections among related visual images:

When confronted with a new visual form, the focus of cognition often becomes the relationship between visual forms and their associated meanings, rather than a particular object. This *intergraphicality* is at work when images cue references to and cognitively integrate with other others, building a conceptual network of imagery and meaning. (Freedman, 1994b, p. 162)

The postmodernist concept of intergraphicality has several curricular implications for art educators:

■ the production of artifacts is not the primary *raison d'être* for art activities in elementary and secondary schools

■ students are likely to link artifacts with images derived from popular and ethnic cultures

■ creating and viewing artifacts are instructional activities designed primarily to raise intra- and inter-personal social consciousness

■ visual interpretation of artifacts is frequently undertaken before analysis (Phillips, 1995) because recognition and association are closely tied to the construction of meaning.

■ *What pedagogic principles guide reconstructionist art education?*

The following general pedagogic principles are offered as a guide to educators devising reconstructionist curricula:

■ study should begin with the students' phenomenological world

■ students' understandings must be broadened with an historical perspective so that students see themselves as part of a larger tradition

■ a cross-cultural perspective is essential to facilitate an understanding of art as diverse, humanly authored and maintained

■ an orientation toward the future must be developed where alternative possible futures are offered and scenarios for change are articulated. (Duncum, 1991, p. 54)

These pedagogic principles are compatible with the more specific strategies previously outlined in *Figure 4: Multicultural Art Education Position Statements* (Wasson, Stuhr & Petrovich-Mwaniki, 1990) on page 51.

■ *How can one describe reconstructionist classroom dynamics?*

Art studios have traditionally exhibited many elements associated with the reconstructionist classroom, such as peer-as-mentor and teacher-as-facilitator. For educators unfamiliar with studio-based teaching and learning, however, the heavy emphasis placed upon diversity in reconstructionist classrooms may at first be difficult to accommodate:

> In contrast to inquiry models that attempt to compare multiple views in order to find one best answer, feminist models acknowledge a myriad of both problems and solutions, which can be compared and related to each other without being categorized as inferior or superior. (Sandell, 1991, p. 182)

The significant contributions made by feminists to reconstructionist pedagogy are clearly evident in the practical instructional suggestions contained in *Figure 7: Gender Considerations in Art Education* (Sherman, 1982; Van Reeuwyk, 1990).

1.	Are the girls in the classroom relied on to do the "helping" activities?
2.	Are the boys the ones who are asked to move the heavy objects or do the more manual functions in a classroom?
3.	Are individual social experiences considered in the evaluation of a student's work?
4.	Are both males and females encouraged to explore and develop ideas about their own body images that transcend the mass media stereotypes?
5.	Is disorderliness in art work labelled as feminine? Is organization in art work seen as masculine?
6.	Are differences in boys' and girls' levels of moral development recognized when it comes to caringness, sensitive critiquing of others, stealing, or aggression?
7.	Are female students less willing to do the "messy" work? Are cleanliness and purity considered feminine qualities?
8.	Is dependency rewarded in girls and independency rewarded in boys?
9.	Are students made aware of male and female role models in art education?
10.	Do girls choose colours such as pink and yellow, that are considered more feminine, while boys choose colours such as brown and black?

Figure 7: Gender Considerations in Art Education

(Sherman, 1982; Van Reeuwyk, 1990)

- *What skills do teachers need for reconstructionist art education?*

The postmodernist emphasis upon meaning rather than form requires teachers to decode sign systems (semiotics) and deconstruct visual images. Anthropological research, such as ethnography, can assist in these tasks. Some specific ethnographic techniques which teachers might wish to employ include: on-site observing, participant observing, journal and diary keeping, note keeping, photographing and filming, tape recording, map and chart making, and survey taking. The implementation of reconstructionist curricula also requires teachers to cultivate a repertoire of culturally-sensitive instructional strategies, keeping in mind that preferred learning styles are culturally, rather than genetically, determined (Wasson, Stuhr & Petrovich-Mwaniki, 1990).

- *What skills do students need for reconstructionist art education?*

Along with their teachers, students need to be well-versed in ethnographic research techniques (*see previous paragraph*) so that they are able to analytically access and critically assess meanings embedded within artifacts. Due, however, to their extended exposure to traditional models of art education, the overwhelming majority of which remain predominantly modernist, their primary task involves a fundamental re-orientation in their understanding of studio production:

> As producers themselves, their challenge is not to produce novel forms but to produce work which meaningfully and critically interprets the potentially infinite array of cultural forms and interactions. (Pearse, 1992, pp. 250-251)

- *What might a curriculum unit in reconstructionist art look like?*

Generally speaking, reconstructionist curricula consist of three separate instructional phases:
- developing awareness in students of their present cultural value systems
- expanding value systems through exposure to alternate world views
- challenging students to actively create a more equitable future. (Haynes, 1995)

Art education can play a decisive role within reconstructionist curricula by providing students with opportunities to endow postmodernist concepts and personal values with concrete, physical forms. For Deborah Hayne's university students, this involves the creation of a simple 6'x 12' wall mural which acts as a focal point for class discussions. A more comprehensive approach to reconstructionist art curricula has been undertaken by Toronto secondary school teacher Susan Brown (1994) in the following curriculum unit entitled: "Investigations in Personal Identity, Art, and Culture."

■ Investigations in Personal Identity, Art, and Culture

This unit assists secondary school students discover what **multicultural** means through visual experience. Several different perceptual lenses on culture and personal experience are employed to assist students in their investigations.

■ Discovering the Culture Within

First, there is the perceptual lens of personal history and identity. The more that students are encouraged to be reflective about themselves, the more they may be prepared to reflect upon people and things beyond themselves. By creating personally significant symbols students increase their understanding of how artists in other societies engage in visual storytelling or create art that is unique. When students create personal totems or symbols they extend and transform their internal sense of identity into recognizable, culturally objectified forms. Such investigations into the realms of personal identity and history are key to introducing the concept of personal culture, while maintaining the validity of the students' own experiences. The art of culturally reading artifacts expands student understanding of form as related to function and meaning.

■ Art, Culture, and Censorship

Reaching beyond the personal/perceptual approach, students may also be challenged by engaging in more anthropological ways of seeing. One particularly successful activity revolves around having students analyze forms of money from various cultures. While visually involved and critically thinking, they collect ideas about cultural values and compare visual biases in style, content, or technological sophistication. Students can go on to debate how culture influences what we see, our concept of world view, and censorship.

■ Multicultural Art Research Assignment

After being introduced to personal and anthropological processes, students develop a more holistic view of culture and its visual forms by pursing a personally significant art/historical study. Perceptual conventions of art history (description, analysis, interpretation, and significance) provide the foci for independent study. The results of independent research are shared through class presentations. Consequently, the students have an opportunity to enrich their design work by integrating and applying new visual and cultural insights. As a final cultural outreach experience, the students are invited to produce and curate a public exhibition of their own work.

■ A New Visual Tradition From Cross-Cultural Design

To support these activities, field trips are arranged to local museums. Specific museum study activities are based on the collections which the students visit. Local professional artisans are also invited to work with the students.

Discovering the Culture Within

■ **Discovering Personal Metaphors through Form**

 Draw responses to the following questions on newsprint divided into 4 areas:

■ *If you could be any **animal**, which would it be?*
 Would your creature fly, swim, or run?
 Try to show it.

■ *If your personality took the form of an **environment**, what would it look like?*
 Is your scene constructed or natural, desert or jungle, mountain or plain?
 Try to describe it.

■ *What form would you take if you were transformed into a **container**?*
 Would your form hold liquids or solids?
 Is your form round or square, tall or short, open or closed?
 Try to draw it.

■ *What style of **vehicle** would you choose to represent yourself?*
 Would your mode of transportation be fast or slow, simple or complex, aerodynamic or comfortable?
 Try to illustrate it.

Animal	Environment
Container	Vehicle

■ **Synectic Thinking and 3D Design**

 Using the personal metaphors that you have created, **build a 3D form**.
 Use bristol board, utility knife, and tape to construct your composite form.

■ **Expressive Rendering**

 Find the most interesting or unusual view of your completed 3D form and **make a monochromatic or tonal study** of it. Try to communicate a mood or emotion in the way your rendering is composed and the media are applied.
 Use cartridge paper and your own choice of drawing media.
 Place the rendering together with this sheet in your studio information file.

Art, Culture, and Censorship

■ ## Rules of the Censorship Game

1. The key premise of the game is that the artforms of a culture are determined by the culture's environment, social structure, key beliefs, and value systems (religious, superstitious, and philosophical).

and

The artforms of a culture provide visual clues to the values and attitudes prevalent in that culture.

2. One of the basic cultural profiles will be assigned to each group of student censors.

3. Each group of censors must augment its basic cultural profile in order to determine the values which influence aesthetic preferences in that specific culture.

4. From a storehouse of art the censors:
 ■ **select one key artwork which could be exhibited in their national museum**
 and
 ■ **designate one work which would not be accepted nor valued as a work of art in their culture.**

5. The censors' selections, along with the cultural and aesthetic rationales, are presented to the class.

6. The censors' completed:
 ■ **cultural profile**
 ■ **description/analysis of the two selected works**
 ■ **rationales for selection/censorship**
 must be handed in for evaluation.

Cultural Profile A	**Values/Aesthetic Preferences**
mountain dwellers *geographically isolated* *pastoral/agrarian economy* *matriarchal government*	
Cultural Profile B	**Values/Aesthetic Preferences**
desert dwellers *exist between 2 advanced cultures* *nomadic raiders* *monarchical government*	
Cultural Profile C	**Values/Aesthetic Preferences**
coastal dwellers *sea-faring* *aqua-cultural economy* *democratic government*	
Cultural Profile D	**Values/Aesthetic Preferences**
city dwellers *technologically advanced* *information-based economy* *oligarchical government*	
Cultural Profile E	**Values/Aesthetic Preferences**
Arctic dwellers *primitive technologies* *hunter-gatherers* *theocratic government*	

Multicultural Art Research Assignment

■ **Cultural Research Kit** *or* **Didactic Panels**

Step 1

Select a specific culture upon which to base an intensive study.

Step 2

Focus your research and **collect visual and verbal information** on:

■ the influence of the **physical environment** on the form and function of art
■ the influence of **magic, superstition,** and **religion** on the form and function of art
■ the influence of **social structure** on the form and function of art
■ an analysis of **artistic style:** important and characteristic motifs, visual symbols, and design elements.

Step 3

Organize and summarize your research into:

■ an instructional illustrated essay
 museum quality didactic panels + 1000 words + diagrams/illustrations
 or
■ an illustrated museum guide or brochure
 1000 words + diagrams/illustrations
 or
■ a sound & light presentation with accompanying script
 5-10 minute slide show + audiotape and/or 1000 word script
 or
■ an instructional video with question & answer sheets
 5-10 minute video + 500 words

PREPARATION *1 2 3 4 5*

Evidence of careful preparation:
A/V equipment set-up
classroom arranged
handouts ready
commentary/performance apparently well-rehearsed and well-timed

VISUAL INFORMATION *1 2 3 4 5*

Selection and presentation of visual examples:
clear, informative images
variety of visual examples, including a key artifact
examples directly related to assigned areas of research
coherent, logical, interesting organization of information

VERBAL INFORMATION *1 2 3 4 5*

Selection and presentation of written and/or oral information:
clear expression of ideas
coherent organization of information
written and/or oral information directly related to assigned areas of research
significant relationships between verbal information and visual examples

INSTRUCTIONAL EFFECTIVENESS *1 2 3 4 5*

Engagement and instruction of the class:
opportunity for active learning: games, questions, handouts, response sheets
clear opening, middle, and summary to presentation
informative coverage of all assigned areas of research

ATTITUDE & CREATIVITY *1 2 3 4 5*

Style and effort demonstrated:
imaginative and original delivery of information
confidence in and understanding of topic selected
careful crafting of presentation as-a-whole

A New Visual Tradition
From Cross-Cultural Design

■ Museum Study: **Museum for Textiles**

Look back at all of the verbal and visual information that you have accumulated during this field trip: decorative motifs, sample colour palettes, forms, imagery, materials, and techniques.

Now...

Imagine yourself as a **cultural engineer** in the future and all you have is the collection of museum study documentation as evidence of an extinct historical culture.

■ *What **name** would you give the extinct culture?*

■ *How would you reconstruct a complete, artistically-unified **mutant artifact**?*
Use as much of the visual information in the collection as possible.
Articles could be clothing, furniture, architectural forms, tools, utensils, etc.
You must show at least 3 alternative plans for a reconstruction.

■ *How would a **museum quality illustration** of the artifact look?*
Use multitone and polychrome on cartridge or watercolour paper.

■ *What information would accompany the artifact to **establish identity and cultural significance**?*

■ Create the **mounted or matted illustration** and produce an **informative identification panel** to accompany it.

	GRENFELL	YORUBA	CHINESE
Type of Textile			
Technique			
Subject Matter			
Significance			
Cultural Function			
Artist's Role			
Environmental Influences			
Cultural Influences			
Colour/Tonal Palette			
Shape/ Form/ Motif			
Pattern			
Sample ID Label			

■ References

Abra, J. (1988). Is creative ability widespread? *Canadian Review of Art Education, 15*(2), 69-89.

Arendt, H. (1986). Communicative power. In S. Lukes (Ed.), *Power.* New York, NY: New York University Press.

Bachmann, D. & Piland, S. (1978). *Women artists: An historical, contemporary, and feminist bibliography.* Metuchen, NJ: Water Press.

Banks, J. (1986). Multicultural education: Development, paradigms and goals. In J. Banks & J. Lynch (Eds.), *Multicultural education in western societies.* London, UK: Holt, Rinehart & Winston.

Banks, J. & Banks, C. (1993). *Multicultural education: Issues and perspectives.* Boston, MA: Allyn & Bacon.

Benhabib, S. (1987). The generalized and the concrete other. In S. Benhabib & D. Cornell (Eds.), *Feminism as critique.* Minneapolis, MN: University of Minnesota Press.

Billings, M. (1995). Issues vs. themes: Two approaches to a multicultural art curriculum. *Art Education, 48*(1), 21-24, 53-56.

Blaikie, F. (1992a). Thoughts concerning a feminist emphasis in art education. *Art Education, 45*(2), 49-52.

_____. (1992b). Modernism, postmodernism, and teaching secondary school art. *Education Insights, 1*(1), 18-23.

_____. (1994a). A case study on a township art teacher in South Africa: *Donatello* in Kwa Mashu. *Journal of the Ontario Society for Education through Art, 23*, 55-59.

_____. (1994b). Twenty pairs of scissors, and a small amount of glue: Getting by in township schools in South Africa. *Art Education, 47*(3), 52-56.

Blandy, D. & Congdon, K. (Eds.). (1987). *Art in a democracy.* New York, NY: Teachers College Press.

_____. (1990). Pornography in the classroom: Another challenge for the art educator. *Studies in Art Education, 32*(1), 6-16.

Boffin, T. & Fraser, J. (Eds.). (1991). *Stolen glances: Lesbians take photographs.* London, UK: Pandora Press.

Boyer, E. (1985). Art as language: Its place in the schools. In *Beyond creating: The place for art in America's schools* (pp. 9-10). Los Angeles, CA: Getty Center for Education in the Arts.

Bracey, T. (1990). An art education for the 2020s: One that is truly moral. *Canadian Review of Art Education, 17*(1), 37-49.

Brommer, G. (1981). *Discovering art history.* Worcester, MA: Davis.

Brown, S. (1994). Multicultural art: Practical investigations in personal identity, visual arts, and culture. *Journal of the Canadian Society for Education through Art, 25*, 13-21.

Burgin, V. (1982). *Thinking photography*. London, UK: Macmillan.

Burton, J., Lederman, A. & London, P. (Eds.). (1988). *Beyond DBAE: The case for multiple visions of art education*. North Darmouth, MS: Peter London.

Calouste Gulbenkian Foundation. (1982). Arts education and the cultural heritage: In *The arts in schools: Principles, practice and provision*. London, UK: Author.

Caw, J. (1900). The art work of Mrs. Traquair. *The Art Journal*, 143-148.

Chalmers, F.G. (1990). South Kensington in the farthest colony. In D. Soucy & M. Stankiewicz (Eds.), *Framing the past: Essays on art education* (pp. 71-86). Reston, VA: National Art Education Association.

_____. (1992a). The origins of racism in the public school art curriculum. *Studies in Art Education, 33*(3), 134-143.

_____. (1992b). D.B.A.E. as multicultural education. *Art Education, 45*(3), 16-24.

_____. (1993). Who is to do this great work for Canada? South Kensington in Ontario. *Journal of Art & Design Education, 12*(2), 161-178.

Chatman, L. (1993). A bright future awaits minorities in art education. *Art Education, 46*(4), 21-24.

Cixous, H. (1981). The laugh of the Medusa. In E. Marks & I. de Courtivron (Eds.), *New French feminisms* (pp. 245-264). New York, NY: Schoken Books.

Clark, R. (1987). *Aesthetic self-disclosure in visual arts*. Unpublished doctoral dissertation. University of Toronto.

_____. (1991). Art as an emergent school subject: Perspectives and a proposal from Ontario. *Studies in Art Education, 32*(4), 220-229.

_____. (1992a). Aesthetic self-disclosure in art. *Canadian Review of Art Education, 19*(1), 48-59.

_____. (1992b). Fundamentalists in the classroom: The special needs of the well-behaved child. *Journal of the Ontario Society for Education through Art, 21*, 35-48.

_____. (1993). Common, superior, and accomplishments: The roots of art education in Ontario curricula. *Journal of the Ontario Society for Education through Art, 22*, 35-45.

_____. (1994). *Art education: A Canadian perspective*. Toronto, Ont.: Ontario Society for Education through Art.

_____. (1995). Nurturing art education: The efficacy of integrated arts curricula. *Canadian Review of Art Education, 22*(1), 1-16.

Cole, M. (1990). *Cultural psychology: A once and future discipline?* Center for Human Information Processing, University of California, San Diego.

Collins, G. (1995). Explanations owed my sister: A reconsideration of feminism in art education. *Studies in Art Education, 36*(2), 69-83.

Collins, G. & Sandell, R. (1984). *Women, art and education.* Reston, VA: National Art Education Association.

_____. (1992). The politics of multicultural art education. *Art Education, 45*(6), 8-13.

Commission on Excellence in Education. (1983). *A nation at risk: The imperatives of educational reform.* Washington, DC: U.S. Government Printing Office.

Congdon, K. (1989). Multi-cultural approaches to art criticism. *Studies in Art Education, 30*(3), 176-184.

Cooper, E. (1994). *The sexual perspective: Homosexuality and art in the last 100 years in the west.* London, UK: Routledge & Kegan Paul.

Cormack, W. (1991). On the struggle for school-based arts. *Design for Arts in Education, 92*(3), 40-45.

Courtney, R. (1980). *The dramatic curriculum.* Vancouver, BC: Pacific Educational Press.

_____. (1982). *Re-play: Studies of human drama in education.* Toronto, Ont.: OISE Press.

_____. (1988). *No one way of being: A study of the practical knowledge of elementary arts teachers* (Contract 0634 ON03699). Toronto, Ont.: Ontario Ministry of Government Services (MGS) Publications Services.

_____. (1989). *Play, drama & thought: The intellectual background to dramatic education* (4th ed., rev.). Toronto, Ont.: Simon & Pierre.

Danto, A. (1981). *The transfiguration of the commonplace.* Cambridge, MA: Harvard University Press.

Delacruz, E. (1995). Multiculturalism and art education: Myths, misconceptions, misdirections. *Art Education, 48*(3), 57-61.

Devereaux, M. (1990). Oppressive texts, resisting readers and the gendered spectator: The new aesthetics. *Journal of Aesthetics and Art Criticism, 48*(4), 337-347.

Dreyfus, H. & Dreyfus, S. (1984). Putting computers in their proper place: Analysis versus intuition in the classroom. *Teachers College Record, 85*(4), 578-601.

Dubinsky, L. (1996). The artifact as narrative. *Journal of the Canadian Society for Education through Art, 27*(1), 23-30.

Dufrene, P. (1994). A response to Mary Erickson: It is time to redefine "western" and "non-western" art or when did Egypt geographically shift to Europe and Native Americans become non-western?" *Studies in Art Education, 35*(4), 252-253.

Duncum, P. (1990). Clearing the decks for dominant culture: Some first principles for a contemporary art education. *Studies in Art Education, 31*(4), 207-215.

_____. (1991). Varieties of cultural literacy in art education. *Canadian Review of Art Education, 18*(1), 45-59.

Ecker, G. (Ed.). (1985). *Feminist aesthetics*. Boston, MA: Beacon.

Efland, A. (1990a). *A history of art education: Intellectual and social currents in teaching the visual arts*. New York, NY: Teachers College Press.

_____. (1990b). Art education in the twentieth century: A history of ideas. In D. Soucy & M. Staniewicz (Eds.), *Framing the past: Essays on art education* (pp. 117-136). Reston, VA: National Art Education Association.

Eisner, E. (1973-74). Examining some myths in art education. *Studies in Art Education, 15*(3), 7-16.

_____. (1987). The role of discipline-based art education in America's schools. *Art Education, 40*(5), 6-26, 43-45.

_____. (1994). Revisionism in art education: Some comments on the preceding articles. *Studies in Art Education, 35*(3), 188-191.

Elam, S. (1990, September). The 22nd annual Gallup poll of the public's attitudes toward the public schools. *Kappan, 72*(1), pp. 41-45.

Erickson, M. (1979). An historical explanation of the schism between research and practice in art education. *Studies in Art Education, 20*(2), 5-13.

_____. (1994). Evidence for art historical interpretation referred to by young people and adults. *Studies in Art Education, 35*(2), 71-78.

Erikson, E. (1963). *Childhood and society* (2nd ed.). New York, NY: W.W. Norton.

Fehr, D. (1994). Promise and paradox: Art education in the postmodern arena. *Studies in Art Education, 35*(4), 209-217.

Feldman, E. (1982). *The artist*. Englewood Cliffs, NJ: Prentice-Hall.

_____. (1987). *Varieties of visual experience* (3rd ed.). Englewood Cliffs, NJ: Prentice-Hall.

Fine, E. (1978). *Women and art: A history of women painters and sculptors from the Renaissance to the 20th century*. Montclair, NJ: Allanheld & Schram.

Fleming, W. (1991). *Arts & ideas* (8th ed.). Toronto, Ont.: Holt, Rinehart and Winston.

Freedman, K. (1994a). About this issue: The social reconstruction of art education. *Studies in Art Education, 35*(3), 131-134.

_____. (1994b). Interpreting gender and visual culture in art classrooms. *Studies in Art Education, 35*(3), 157-170.

Garber, E. (1990). Implications of feminist art criticism for art education. *Studies in Art Education, 32*(1), 17-26.

_____. (1992). Feminism, aesthetics, and art education. *Studies in Art Education, 33*(4), 210-215.

Garber, E. & Gaudelius, Y. (1992). Object into subject: Feminism, art, education, and the construction of self. *Canadian Review of Art Education, 19*(1), 12-33.

Gardner, H. (1983). *Frames of mind: The theory of multiple intelligences.* New York, NY: Basic Books.

_____. (1989). Zero-based arts education: An introduction to ARTS PROPEL. *Studies in Art Education, 30*(2), 71-83.

Getty Center for Education in the Arts. (1985). *Beyond creating: The place for art in America's schools.* Los Angeles, CA: Author.

_____. (1989). *Inheriting the theory: New voices and multiple perspectives on DBAE.* Los Angeles, CA: Author.

Gombrich, E. (1989). *The story of art* (15th ed.). Englewood Cliffs, NJ: Prentice-Hall.

Goodson, I. (1987). *School subjects and curriculum change: Studies in curriculum history* (rev. ed.). London, UK: Falmer Press.

Gracyk, T. (1987). Pornography as representation: Aesthetic considerations. *Journal of Aesthetic Education, 21*(4), 103-121.

Grant, C. & Sleeter, C. (1989). Race, class, gender, and disability in the classroom. In J. Banks & C. Banks (Eds. 2nd ed.), *Multicultural education issues and perspectives* (pp. 48-68). Boston, MA: Allyn and Bacon.

Grigsby, J.E. (1990). Afro-American culture and the white ghetto. In B. Young (Ed.), *Art, culture, and ethnicity* (pp. 61-68). Reston, VA: National Art Education Association.

Habermas, J. (1971). *Knowledge and human interests.* Boston, MA: Beacon.

Hagaman, S. (1990). Feminist inquiry in art history, art criticism, and aesthetics: An overview for art education. *Studies in Art Education, 32*(1), 27-35.

Hagan, L. (1898). Lady artists in Germany. *International Studio, 4*, 91-99.

Hall, C. (1993). Women artists in Canada: A history of our own. *Canadian Review of Art Education, 20*(1), 24-29.

Hamblen, K. (1988). What does DBAE teach? *Studies in Art Education, 41*(2), 23-24, 33-35.

_____. (1990). Beyond the aesthetic of cash-culture literacy. *Studies in Art Education, 31*(4), 216-225.

_____. (1993, April). *The emergence of neo-DBAE.* Paper presented at the annual meeting of the American Educational Research Association, Atlanta, GA. (ERIC Document Reproduction Service No. ED 364 459).

Hart, L. (1991a). Aesthetic pluralism and multicultural art education. *Studies in Art Education, 32*(3), 145-159.

_____. (1991b). The national art education policy and the art of immigrant students. *Canadian Review of Art Education, 18*(2), 126-135.

Haynes, D. (1995). Teaching postmodernism. *Art Education, 48*(5), 23-24, 45-50.

Heartney, E. (1988). A necessary transgression. *New Art Examiner, 16*(3), 20-23.

Henley, D. (1991). Affective expression in post-modern art education: Theory and intervention. *Art Education, 44*(2), 16-22.

Hicks, L. (1990). A feminist analysis of empowerment and community in art education. *Studies in Art Education, 32*(1), 36-46.

_____. (1994). Social reconstruction and community. *Studies in Art Education, 35*(3), 149-156.

Holt, D. (1990). Post-modernism vs. high modernism: The relationship to D.B.A.E. and its critics. *Art Education, 43*(2), 42-46.

Honeychurch, K. (1995). Extending the dialogues of diversity: Sexual subjectivities and education in the visual arts. *Studies in Art Education, 36*(4), 210-217.

Huber, B. (1990). *Feminism, Manitoba artists for women's art (M.A.W.A.), and art education: A Women-centered examination of the learning experience in the mentor program of M.A.W.A.* Unpublished master's thesis, University of Manitoba, Winnipeg, Man.

Husserl, E. (1964). *The Paris lectures* (P. Koestenbaum, Trans.). The Hague, The Netherlands: Martinus Nijhoff.

Irwin, R. (1991, November). Charismatic leadership for women arts educators. Paper presented at the Annual Meeting of the Canadian Society for Education through Art, Victoria, British Columbia.

_____. (1992). A profile of an arts supervisor: A political image. *Studies in Art Education, 33*(2), 110-121.

_____. (1995). *A circle of empowerment: Women, education, and leadership.* Albany, NY: State University of New York Press.

Janson, H. (1986). *A basic history of art* (2nd ed.). Englewood Cliffs, NJ: Prentice-Hall.

Kaplan, E. (1986). Is the gaze male? In M. Pearsall (Ed.), *Women and values: Readings in recent feminist philosophy* (pp. 230-241). Belmont, CA: Wadsworth.

Kauppinen, H. & Diket, R. (Eds.). (1995). *Trends in art education from diverse cultures.* Reston, VA: National Art Education Association.

Kearney, R. (1988). *The wake of imagination: Toward a postmodern culture.* Minneapolis, MN: University of Minnesota Press.

Keith, C. (1995). Politics, art, and education: The positive postmodern challenges to aesthetic and traditional western education. *Canadian Review of Art Education, 22*(1), 40-55.

Kelley, C. (Ed.). (1992). *Forbidden subjects: Self-portraits by lesbian artists.* North Vancouver, B.C.: Gallerie Publications.

Kelly, M. (1983). *Post-partum document.* London, UK: Routledge & Kegan Paul.

Kellogg, R. (1969). *Analyzing children's art.* Palo Alto, CA: National Press Books.

Kindler, A. (1992). Worship of creativity and artistic development of young children. *Journal of the Canadian Society for Education through Art, 23*(2), 12-16.

King, I. (1991). In search of Lowenfeld's proof that coloring books are harmful to children. *Studies in Art Education, 33*(1), 36-42.

Korzenik, D. (1990). Women doing historical research. *Studies in Art Education, 32*(1), 47-54.

Kuhn, T. (1970). *The structure of scientific revolutions.* Chicago, IL: University of Chicago Press.

LaBatte, J. (1991). Nurturing creative/artistic giftedness in American Indian students. *Journal of American Indian Education, 31*(1), 28-32.

Lampela, L. (1995). A challenge for art education: Including lesbians and gays. *Studies in Art Education, 36*(4), 242-248.

_____. (1996). Concerns of gay and lesbian caucuses within art, education, and art education. *Art Education, 49*(2), 20-24.

Langer, S. (1982). Against the grain: A working gynergenic art criticism. *International Journal of Women's Studies, 5*(3), 246-264.

Levin, K. (1979). Farewell to modernism. *Arts Magazine, 54*(2), 90-91.

Linker, K. (1985). A reflection on post-modernism. *Artforum, 24*(2), 104-105.

Lippard, L. (1990). *Mixed blessings: New art in a multicultural America.* New York, NY: Pantheon Books.

Longstreet, W. & Shane, H. (1993). *Curriculum for a new millenium.* Toronto, Ont.: Allyn and Bacon.

Lowenfeld, V. (1947). *Creative and mental growth.* London, UK: Macmillan.

MacGregor, R. (1992). *Post-modernism, art educators, and art education.* (Report No. EDO-SO-92-9). Los Angeles, CA: Getty Center for Education in the Arts. (ERIC Document Reproduction Service No. ED 348 328).

Marsden, W. (1990). Rooting racism into the educational experiences of childhood and youth in the nineteenth and twentieth centuries. *History of Education, 19*(4), 333-353.

May, R. (1975). *The courage to create.* New York, NY: W.W. Norton.

McFee, J. (1986). Cross-cultural inquiry into the social meaning of art: Implications for art education. *Journal of Multi-cultural and Cross-cultural Research in Art Education, 4*(1), 6-16.

Moore, J. (1991). Post-modernism and DBAE: A contextual analysis. *Art Education, 44*(6), 34-39.

Mullen, C. & Chalmers, F.G. (1990). Guest editorial: Culture, society, and art education. *Studies in Art Education, 31*(4), 195-197.

National Education Association. (1894). *Report of the committee of ten on secondary school studies.* Washington, DC: Author.

National Education Association. (1895). *Report of the committee of fifteen on elementary school studies.* Washington, DC: Author.

Nelson, A. & Lalemi, B. (1991). The role of imagery training on Tohono O'odham children's creativity scores. *Journal of American Indian Education, 30*(3), 24-32.

Nelson, K. (1988). Marilyn Monroe. *Art Education, 41*(3), 37-38.

Neperud, R. & Stuhr, P. (1993). Cross-cultural valuing of Wisconsin Indian art by Indians and non-Indians. *Studies in Art Education, 34*(4), 244-253.

Ontario Ministry of Education. (1986). *Visual Arts: Intermediate and Senior Divisions.* Toronto, Ont.: Author.

Parks, M. (1989). Art education in a post-modern age. *Art Education, 42*(2), 10-13.

Pearse, H. (1983). Brother can you spare a paradigm? The theory beneath the practice. *Studies in Art Education, 24*(3), 158-163.

_____. (1992a). Beyond paradigms: Art education theory and practice in a postparadigmatic world. *Studies in Art Education, 33*(4), 244-252.

_____. (1992b). The first to go: Message or myth? *NSCAD Papers in Art Education, 6,* 85-90.

Pepper, S.C. (1942). *World hypotheses: A study in evidence.* Berkeley, CA: University of California Press.

Pettys, C. (1985). *Dictionary of women artists.* Boston, MA.: Smith Press.

Phillips, R. (1995). Thinking and feeling while looking at photographs: A model for photography criticism. *Journal of the Canadian Society for Education through Art, 26*(1), 29-34.

Pike, G. & Selby, D. (1988). *Global teacher, global learner.* Toronto, Ont.: Hodder and Stoughton.

Piper, A. (1993). The logic of modernism: How Greenberg stole the Americans away from a tradition of Euroethnic social content. *Flash Art, 26*(168), 57-58, 118, 136.

Rabinovitz, L. (1980/1981). Issues of feminist aesthetics: Judy Chicago and Joyce Wieland. *Woman's Art Journal, 1*(2), 38-41.

Ravitch, D. (1990). Multiculturalism in the curriculum. *Network News and Views, 9*(3), 1-11.

_____. (1991). Multiculturalism: An exchange. *The American Scholar, 60*(2), 272-276.

Richards, W. (1992). Why in the world would you want to do that? *Queer Muse, 1*, 5-6.

Richardson, J. (1980). *Art: The way it is* (2nd ed.). Englewood Cliffs, NJ: Prentice-Hall.

Rogers, T. & Irwin, R. (1995). A 3D view of art in global education: Difference, diversity, and distance. *Journal of the Canadian Society for Education through Art, 26*(1), 15-21.

Rouse, T. (1984). Faith Ringgold: A mirror of her community. In M. Wallace (Ed.), *Faith Ringgold: Twenty years of painting, sculpture and performance (1963-1983)* (pp. 9-10). New York, NY: Studio Museum in Harlem.

Sacca, E. (1989). Invisible women: Questioning recognition and status in art education. *Studies in Art Education, 30*(2), 122-127.

Sahasrabudhe, P. (1992). Multicultural art education: A proposal for curriculum content, structure and attitudinal understandings. *Art Education, 45*(3), 41-47.

Sandell, R. (1991). The liberating relevance of feminist pedagogy. *Studies in Art Education, 32*(3), 178-187.

Schweickart, P. (1985). What are we doing, really? - Feminist criticism and the problem of theory. *Canadian Journal of Political and Social Theory, 9*(1-2), 148-164.

Shane, H. (1981). *Educating for a new millennium.* Bloomington, IN: Phi Delta Kappa Educational Foundation.

Shannon, H. (1986). The nightmare. *Art Education, 39*(4), 29-30.

Slatkin, W. (1990). *Women artists in history* (2nd ed.). Englewood Cliffs, NJ: Prentice-Hall.

Smith, A. (1992). Copy right, copy wrong, copy cat: The legitimate imitation of images from art's history. *NSCAD Papers in Art Education, 6*, 39-46.

_____. (1993). *Getting into art history.* Toronto, Ont.: Barn Press.

Smith, P. (1988). The role of gender in the history of art education: Questioning some explanations. *Studies in Art Education, 29*(4), 232-240.

_____. (1994). Multicultural issues: Dilemmas and hopes. *Art Education, 47*(4), 13-17.

Smith, R. (1992a). Building a sense of art in today's world. *Studies in Art Education, 33*(2), 71-85.

_____. (1992b). Problems for a philosophy of art education. *Studies in Art Education, 33*(4), 253-266.

Soucy, D. (1989). More than a polite pursuit: Art education for women in Nova Scotia, 1887-1930's. *Art Education, 42*(2), 23-24, 37-40.

Soucy, D. & Stankiewicz, M. (Eds.). (1990). *Framing the past: Essays on art education.* Reston, VA: National Art Education Association.

Sousa, J. (1988). Into the world there came a soul called Ida. *Art Education, 40*(1), 39-40.

Sparling, M. (1996). Enlarging the access: Developing an awareness of the visual arts in the young. *Journal of the Canadian Society for Education through Art, 27*(1), 38-43.

Sparrow, W. (1900). Some drawings by Mrs. Farmiloe. *The Studio, 18*, 172-179.

Stankiewicz, M. (1982). Woman, artist, art educator: Professional image among women art educators. In M. Stankiewicz & E. Zimmerman (Eds.), *Women art educators* (pp. 30-48). Bloomington, IN: Indiana University Press.

Stephen, V. (1996). Teaching through exhibitions: Exhibitions designed for learning. *Journal of the Canadian Society for Education through Art, 27*(1), 17-22.

Stokrocki, M. (1994). A case study in ethnographic storytelling. *Art Education, 47*(4), 61-69.

Stone, J. (1995a). Global transformation from the perspective of an art museum educator. *Journal of the Canadian Society for Education through Art, 26*(1), 35-39.

_____. (1995b). The global gallery: Practising education with a global perspective in a museum environment. *Journal of the Ontario Society for Education through Art, 24*, 59-68.

Stuhr, P. (1994). Multicultural art education and social reconstruction. *Studies in Art Education, 35*(3), 171-178.

Stuhr, P., Petrovich-Mwaniki, L. & Wasson, R. (1992). Curriculum guidelines for the multicultural art classroom. *Art Education, 45*(1), 16-24.

Sullivan, G. (1993). Art-based art education: Learning that is meaningful, authentic, critical and pluralist. *Studies in Art Education, 35*(1), 5-21.

Templeton, D. (1990). Developmentalism: Undo, undid, undone. *Canadian Review of Art Education, 17*(1), 29-36.

Tomhave, R. (1992). Value bases underlying conceptions of multicultural education: An analysis of selected literature in art education. *Studies in Art Education, 34*(1), 48-60.

Turner, R. (1990). Gender-related considerations for developing the text of art instructional materials. *Studies in Art Education, 32*(1), 55-64.

Van Manen, M. (1990). *Researching lived experience: Human science for an action sensitive pedagogy.* London, Ont.: Althouse Press.

_____. (1991). *The tact of teaching: The meaning of pedagogical thoughtfulness.* London, Ont.: Althouse Press.

Van Reeuwyk, J. (1990). *Feminism's response to the art world and art education.* Unpublished master's thesis, Simon Fraser University, Burnaby, British Columbia.

Vastokas, J. (1996). Art through the ages: Learning for the new world system. *Journal of the Canadian Society for Education through Art, 27*(1), 4-9.

Wainio, C. (1995). Struggling with modernism in the academy. *Canadian Review of Art Education, 21*(2), 119-126.

Wasson, R., Stuhr, P. & Petrovich-Mwaniki, L. (1990). Teaching art in the multicultural classroom: Six position statements. *Studies in Art Education, 31*(4), 234-246.

Waugh, J. (1990). Analytic aesthetics and feminist aesthetics: Neither/nor? *Journal of Aesthetics and Art Criticism, 48*(4), 317-326.

Weinberg, J. (1993). *Speaking for vice: Homosexuality in the art of Charles Demuth, Marsden Hartley, and the first American avant-garde.* New Haven, CT: Yale University Press.

West, C. (1993). *Prophetic reflections: Notes on race and power in America.* Monroe, ME: Common Courage Press.

Wilson, B. (1988). Name brand, generic brand, and popular brands: The boundaries of discipline-based art education. In *Issues in Discipline-Based Art Education: Strengthening the Stance, Extending the Horizons - Seminar Proceedings* (pp. 61-65). Los Angeles, CA: The Getty Center for Education in the Arts.

_____. (1992). Postmodernism and the challenge of content: Teaching teachers of art for the twenty-first century. In N. Yakel (Ed.), *The future: Challenge of change* (pp. 99-113). Reston, VA: National Art Education Association.

Wolcott, A. (1996). Is what you see what you get? A postmodern approach to understanding works of art. *Studies in Art Education, 37*(2), 69-79.

Wolff, J. (1990). Questioning the curriculum: Arts, education and ideology. *Studies in Art Education, 31*(4), 198-206.

Young, B. (1995). Two young interviewers get a sense of heritage from African/American artist and educator Dr. J. Eugence Grigsby, Jr. *Art Education, 48*(2), 37-42.

Young, I.M. (1990). The ideal community and the politics of difference. In S. Benhabib & D. Cornell (Eds.), *Feminism as critique.* Minneapolis, MN: University of Minneapolis Press.

Young, R. (1995). Multicultural education in the United States from a historical and social perspective. *Multicultural Education Journal, 13*(1), 12-20.

Zerffi, G. (1876). *A manual of the historical development of art.* London, UK: Hardwicke and Bogue.

Zimmerman, E. (1991). Art education for women in England from 1889-1910 as reflected in the Victorian periodical press and current feminist histories of art education. *Studies in Art Education, 32*(2), 105-116.

▪ Quotations

■ Index